Paul Gauguin

HFINE
1400
6438

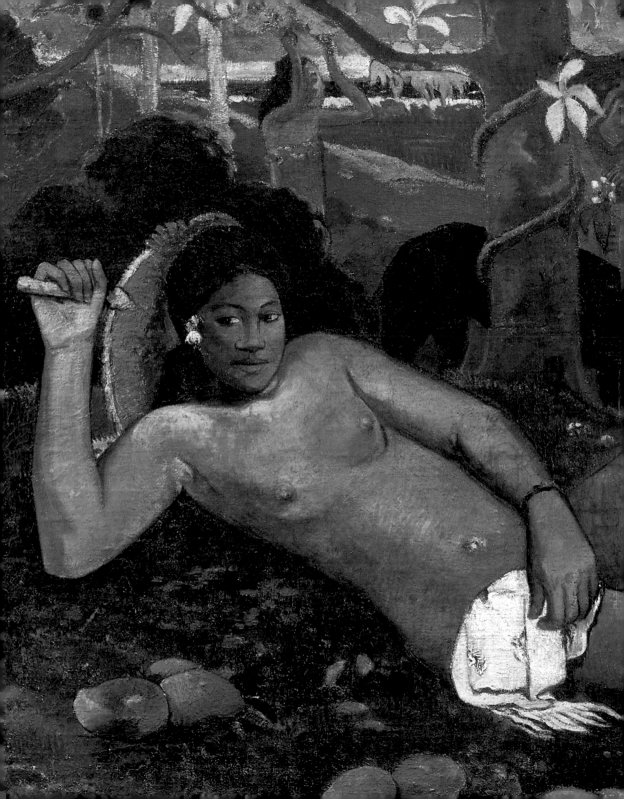

Paul Gauguin

Nancy Ireson

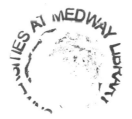

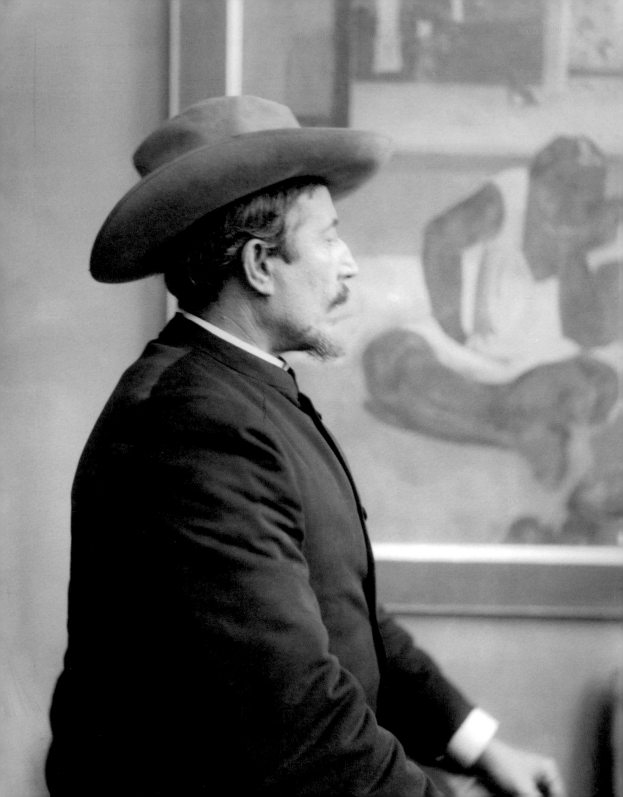

Gauguin was a monster. That is to say, he can't be pigeon-holed into any one of the moral, intellectual or social categories that suffice to define most individuals...[1]

In 1904, just months after Gauguin's death in the Marquesas Islands, the writer Victor Ségalen wrote an account of his visit to the painter's last studio.[2] No doubt people were curious. Gauguin's work had sparked horror and admiration. His lifestyle – his travels, his mistresses, his complicated relationships with peers in the art world – had attracted equally disparate reactions. At the start of his text, Ségalen felt the need to offer a warning, to remind his readers that this character would not comply with their principles. To judge his art, it seemed, they would need to look beyond familiar conventions.

This dispassionate approach remains helpful today. People in Europe may still associate the places shown or evoked in Gauguin's work with ideas of escape and fantasy. But a multicultural society rests ill at ease with the knowledge that his travels were also a hunt for a society that was 'savage', archaic or uncivilised. The prejudices of a colonial age – reinforced or challenged – are only one element of these paintings and sculptures, but the ingredient remains unpalatable. And to consider Gauguin's approach to human relationships is no less comfortable a task. He left his wife and family in France, abandoned his child bride in Tahiti, argued with friends and alienated his supporters. Yet to grasp the significance of Gauguin is not to excuse his behaviour. To appreciate the distinctive physical qualities of his output (heightened colour, untreated paint surfaces, rough carving and modelling) is not to subscribe to outdated stereotypes. The fact remains that this artist produced a remarkable body of work. To look at the man and the moment, to try and understand it, is the task of this small volume.

Background and early life

In many respects, even before Gauguin was born, his family history was the stuff of legend. His maternal grandmother was Flora Tristan: a pioneering French socialist and feminist, of Peruvian ancestry, who made her name as a woman of letters. His mother Aline Maria Chazal, in contrast, was a quiet young woman. She married Clovis Gauguin, a journalist, and they had two children. Their youngest, Eugène Henri Paul, came into the world on 7 June 1848. However, by 1849, civil unrest in Paris had shattered any hopes of a quiet life. The family set sail for Peru to seek refuge with Aline's relations, but Clovis died before they reached their destination. Forced to adjust to new circumstances, Aline and her children lived with her relatives for the next six years. Paul grew up to speak Spanish much of the time. In later life Gauguin would refer often to his foreign childhood. 'Vincent [van Gogh] sometimes calls me the man who has come from afar and will go far'.[3] He would also paint a portrait of his mother, depicting her as a young woman, in a similarly romantic vein (fig.22).

In 1854, on the request of Paul's paternal grandfather, Guillaume, in Orléans, the family returned to France. But he died soon after and, left with only a small legacy, Aline moved to Paris to earn a living. Paul remained at school in Orléans where he struggled with the language and lessons and became withdrawn. It was while he was at college, seemingly, that he began to carve ⊥ he grew interested in the silver and ceramic objects that his mother had collected during their time in South America – but he had no clear artistic ambitions at this stage.

Parisian respectability

As an older teenager, without a clear career aim, Gauguin took an apprenticeship in the merchant navy. He set out on his first voyage in 1865 on board the *Luzitano* bound for Rio. The post suited him; he worked well. After a second trip – and a promotion – he joined the crew of the *Chili*. They embarked on a journey that took in Panama, Taboga and the Polynesian Islands.

In 1868, by now accustomed to life at sea, he performed his military service in the Navy. After the Franco-Prussian War, and one last voyage, he returned to Paris. However, on his arrival he found his mother's house in ruins (she had died the previous year). It was at this point that he sought out a family friend, Gustave

2. Paul Gauguin
Landscape c.1873
Oil on canvas
50.5 × 81.6
Fitzwilliam Museum,
Cambridge

Arosa, who Aline had appointed as his guardian. This was significant. The wealthy and cultured Arosa found Gauguin a job as a broker's agent on the upmarket Rue Laffitte and exposed him to the works of art in his impressive collection, which included pieces by Eugène Delacroix, Honoré Daumier, Gustave Courbet, Jean-Baptiste-Camille Corot and Camille Pissarro. It was with Arosa's daughter, Marguerite, that Gauguin began to paint.

Now Gauguin established a solid middle-class life. At work he made swift progress and soon became a liquidator. He also fell in love; he married his Danish fiancée, Mette Gad, in 1873. The couple moved into a small flat on the Place Saint-George and, less than ten months later, in 1874, she gave birth to Emil, their first child.

But Gauguin's interest in art grew nonetheless. A landscape produced at around this time suggests that he had begun to gain technical confidence (fig.2). At the office, he met Emil Schuffenecker, an earnest young man intent on making his name as an artist. There was a marked difference in their status – Gauguin, aged 24, earned 3,000 francs a year, whereas Schuffenecker, aged 20, was an office employee on 1,800 francs – but the two became friends.[4]

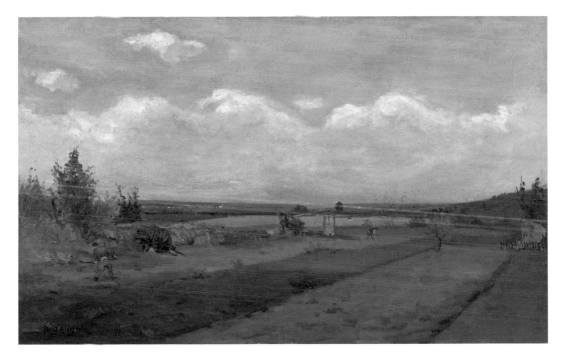

They went on regular sketching trips to the outskirts of the city. They visited the Louvre, they frequented open painting studios and the Académie Colarossi. Mette had experienced a difficult pregnancy and, for a brief moment, Gauguin had spent less time painting. But the baby would provide him with a new model and, despite busy times on the stock market, Gauguin was once again committed to the pursuit of his hobby.

Gauguin the Impressionist

By 1876, the aspiring artist had a work accepted at the prestigious annual Salon. The art that most attracted him, though, was not of the kind displayed in that 'official' arena. This was the year of the second Impressionist exhibition. Interested by what he saw, Gauguin met Pissarro, who became a great mentor and who introduced him to other painters from the Impressionist group.

The stylistic impact of his new connections is evident in a number of his early works. His 1881 *Figures in a Garden* (fig.3) shows a similarly absorbed female subject to Pissarro's *A Wool-Carder* that went on show at the 1880 Impressionist exhibition (fig.4), both described in the same, flickering brushwork. Paul Cézanne and Edgar Degas would also prove particularly useful to his artistic development. Paintings such as the former's *Landscape, Study after Nature*, which Gauguin would have seen at the Impressionist exhibition of 1877 (fig.5), informed the ways in which he now began to flatten

3. Paul Gauguin
Figures in a Garden 1881
Oil on canvas
87 × 114
Ny Carlsberg Glyptotek, Copenhagen

4. Camille Pisarro
A Wool-Carder 1880
Oil on cement
59.9 × 46.4
National Gallery, London

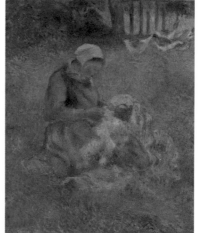

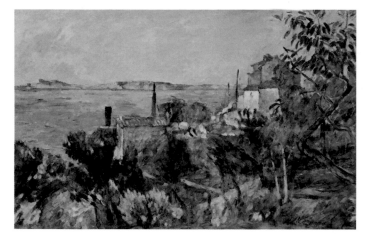

5. Paul Cézanne
Landscape, Study after Nature (The Sea at L'Estaque) 1876
Oil on canvas
42 × 59
Rau Collection, Cologne

perspectival space. And the vague eroticism of *The Little One is Dreaming* (fig.6) might owe something to the latter's *Young Spartans Exercising* (a fixture in Degas's studio; fig.7), with its lithe adolescents and their soft-muscled limbs. But as these comparisons suggest, though Gauguin was not averse to borrowing motifs or styles from other artists, he did so in order to create something that was very much his own.

From the late 1870s, Gauguin's life developed in ever more conflicting directions. Mette had two more children, Aline and Clovis, in 1877 and 1879, but his passion for art pulled him away from his family responsibilities. He became increasingly involved with the Impressionists; having befriended a sculptor who lived nearby, he learnt modelling and carving techniques, which he used to create a statuette for the fourth Impressionist exhibition in 1879. At the 1880 show, he submitted seven paintings and an accomplished portrait bust (fig.23).

However, even within artistic circles, there were tensions. Gauguin was still an amateur artist. Pierre-Auguste Renoir and Claude Monet – perhaps partly because of his presence had already decided not to submit works to the 1880 Impressionist exhibition.[5] By the summer of 1882 he was determined to turn professional. 'I cannot let myself stay in finance and be an amateur painter all my life; I've got it into my head that I'll be a painter...', he explained to Pissarro.[6] He had, after all, received some significant praise; Degas had even purchased a canvas.[7] As 1883 began, Gauguin left his well-paid job, though he

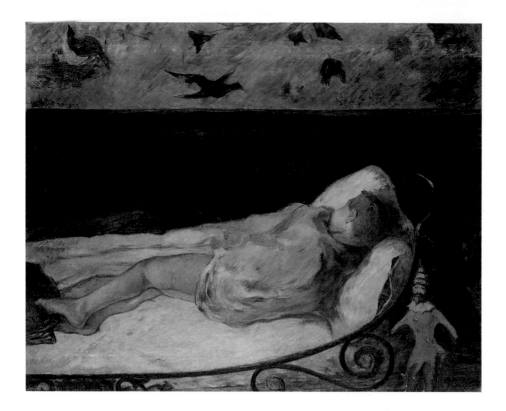

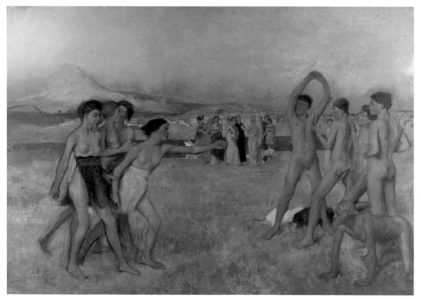

6. Paul Gauguin
*The Little One is Dreaming
(Study)* 1881
Oil on canvas
59.5 × 73.5
Collection Oskar Reinhart
– Am Römerholz –
Winterhur

7. Edgar Degas
Young Spartans Exercising
c.1860
Oil on canvas
109.5 × 155
National Gallery, London

8. Paul Cézanne
The François Zola Dam
1877–8
Oil on canvas
54.2 × 74.2
National Museum of
Wales, Cardiff

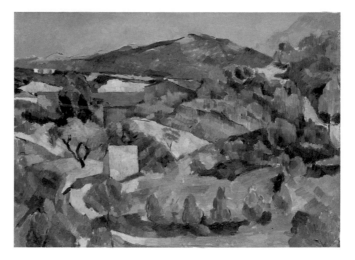

continued to purchase art. It was in July the same year that he acquired *The François Zola Dam* by Cézanne (fig.8).

Yet, despite his confidence, success proved elusive. Funds ran low and Mette was dismayed at the social consequences. When Gauguin moved the family to Rouen in 1884 (fig.24), where he was determined he might find buyers for his art, she went with reluctance.

Unsurprisingly, in the provinces clients were no easier to find than they had been in Paris. Mette and the children returned to her family in Copenhagen. When Gauguin joined them, some six months later, he tried to earn money as a sales representative for a textiles company, but his efforts proved futile. On a trial separation, Gauguin returned to Paris with his son Clovis (fig.25), but he struggled to make ends meet. This did not prevent him from showing once more with the Impressionists in 1886, though his fifteen canvases made little impact. Nonetheless, he was determined not to compromise his ideals and displayed a persistence that he would never quite lose. He refused to show with the likes of Schuffenecker and Georges Seurat at the newly-formed Salon des Indépendants. And he preferred to work as a bill sticker rather than accept a job as an advertising inspector. Perhaps this enforced proximity to poster-art was a further prompt to the 'flatness' of his later paintings. With their bold outlines, blocks of colour and distinctive typography, they share some traits with popular imagery.

A first taste of the 'primitive'

One happy occurrence of 1886 was Gauguin's introduction to the ceramicist Ernest Chaplet. He began to work in clay and, one year later, thanks to the art dealer Theo van Gogh (the brother of the painter, Vincent), he exhibited a selection. This would mark the start of an interest in a new media that he would explore for a period of about eight years; a process that would culminate in the startling stoneware *Oviri*, produced in December 1894 (fig.26).[8]

His interest was fed by a first visit to Pont-Aven in Brittany that summer, as is shown by his distinctive *Vase decorated with Breton scenes* (fig.27) produced back in Paris soon after. The move had been at once artistic and practical. The region was reputed for its 'archaic' character and Gauguin must have been aware of the stereotype.[9] As late as 1902, one social study would describe the Bretons as 'a holy people … the good seed that germinates the fullest grains',[10] and other artists had already settled in the area to find new subjects for their art. Perhaps more importantly, however, he would have known that the cost of living there was low.

This initial stay proved important primarily for the thoughts it nurtured. The artist had already begun to theorise about art and, in his guest house home, he found peers who were keen to listen to his ideas. But as much as he found satisfaction in Brittany – with the costume of the women, the farming and the distinctive practice of Catholicism in the region – he began to thirst for something more. Pont-Aven had acted as a domestic alternative to far-off 'exotic' regions (the idea of the 'primitive' at the time was an ambiguous term that covered everything from child art, to the art of the insane, to the cultural products of non-western societies),[11] but the place was changing fast. Gauguin wished to find peace and quiet, away from 'civilisation', in a pre-modern society; a construction that no doubt existed in his imagination more solidly than it could in any geographic location.

The lure of the exotic

Together with the painter Charles Laval, who he had befriended during his stay in Pont-Aven and who he had depicted in an unusual still life (fig.28), Gauguin set sail for Panama in 1887. But the trip proved disastrous. Panama, exploited by the canal company,

offered only hard work and sickness. In order to fund their passage out, Gauguin became a manual labourer on the project, but he was soon laid off.[12] The pair moved on to Martinique. This, at least, proved positive. They had already noted on their outbound journey that here was 'a marvelous country where there is plenty to keep an artist busy and life is cheap, easy, and the people are affable'.[13] Their stay lasted four months and, during that time, Gauguin grew fascinated by the inhabitants of St-Pierre: their range of skin colours, their poses, their gestures so unlike those he had seen elsewhere (fig.29). This episode alone shows the complexity of judging the artist's attitude to race. His art at this time focused on the black, female, population of the island, effectively editing out its large mixed-race and immigrant communities. This strategy denied the modern reality of the place – nurturing fantasies of a wholesome femininity associated with Martinique – but it also refused to engage with the growing colonial interest in eugenics.[14] Gauguin and Laval lived in a basic hut alongside Creole workers, much to the bemusement of the locals. This choice of lodging was not only cheap; it was also a self-conscious way for the artists to align themselves with a marginalised section of society. The idyll would not last long, however, and as the dysentery he had contracted in Panama ruined his health, Gauguin sought a passage home.

Back to Brittany

The return to Paris offered little comfort. His Martinique paintings found admirers but buyers failed to materialise. Still ill, in February 1888 Gauguin returned to Brittany. 'Here I find a savage, primitive quality', he wrote to Schuffenecker. 'When my wooden shoes echo on this granite ground, I hear the dull, muted, powerful sound I am looking for in painting'.[15]

But here, as elsewhere, Gauguin did not simply paint what he saw. He referred frequently to his visual memory, not least because bad weather prevented much outdoor work. His *Bather in Brittany* of the winter before his Panama trip, for instance, had combined his first-hand experience of rural life with a memory of *Young Girls by the Sea* that one of his artistic idols, Pierre Puvis de Chavannes, had painted some ten years previously (figs.30 and 9). Now he would explore the potential of such motifs more fully. This work and his *Bréton Wrestling*

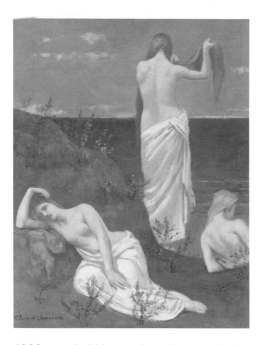

9. Pierre Puvis de Chavannes
Young Girls by the Sea
1879
Oil on canvas
61 × 47
Musée d'Orsay, Paris

1888 revealed his continued interest in the expressive potential of the young male figure, just as his *Ondine* of 1889 (fig.31) would provide a further opportunity to explore the modulations of the female back. Most importantly, however, this stay in Brittany saw the creation of *Vision of the Sermon* (fig.33) and may well have inspired his later *The Wine Harvest at Arles* (fig.32).[16]

It may be that the former work owed something to the influence of Emile Bernard, a young artist who arrived in the town in August 1888 and who produced his *Breton Women in the Meadow* (fig.10) at around the same time. Bernard looked up to Gauguin, and Bernard's own bold use of colour impressed his mentor in turn.

Both artists became increasingly interested in Breton spirituality, something that must have seemed alien given the political secularism of Third Republic France.[17] Accordingly, Gauguin's art began to reveal a greater interest in things unseen, the interior life. He explained that Jacob and the Angel, shown struggling in *Vision of the Sermon*, were seen only in the imagination of the surrounding women (hence the disparate scale of the figures). *The Wine Harvest at Arles* took the inner torment of a fallen woman as its subject. He also started to mythologise his own identity more forcibly. He and Bernard painted

10. Emile Bernard
*Breton Women in
the Meadow* c.1888
Oil on canvas
74 × 82
Private collection

self-portraits, for an exchange initiated by Vincent van Gogh (fig.34).
'I think it's one of my best things', he mused, '… a bandit's head at
first glance, a Jean Valjean [the misunderstood hero of Victor Hugo's
1862 *Les Misérables*], also personifying the Impressionist painter
who is frowned upon and, in the eyes of the world, always carries
a [ball and] chain'.[18]

Sadly, when Gauguin's synthetic style found fame some years later,
it was Bernard who would feel the more hard done by. His own art had
failed to develop in any significant sense and he accused his former
friend of appropriating a style that he himself had invented. But for a
time, at least, each had learnt from the other in ways that were fruitful
and constructive. a statement that would also be true of Gauguin's
relationship with Vincent van Gogh, the recipient of that 'abstract'
self-portrait

Gauguin and van Gogh

Van Gogh was impressed with Gauguin's work – particularly
his studies of Martinique – and had persuaded Theo of its merit.
The artists had developed a friendship through correspondence,
wherein they discussed their ideas about art and life. Gauguin

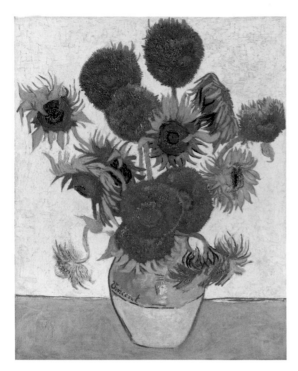

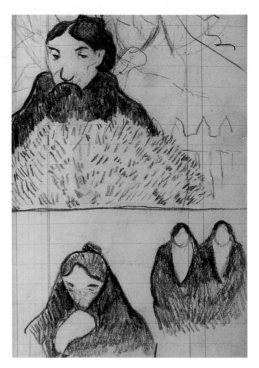

welcomed a new chance to air his opinions to a fellow painter and admirer, and van Gogh was keen for his friend to join him in Arles at Theo's expense. Though he took time to decide, eventually Gauguin made the move towards the end of October 1888.

In anticipation of the visit, van Gogh rearranged the Yellow House where they would live. He painted a canvas of sunflowers to hang in Gauguin's room (fig.11). Enthused by the strong sunlight and sparse landscapes of the region, van Gogh hoped that they might establish a 'Studio of the South', which would attract other artists in turn. The dream, however, remained unfulfilled. Though Gauguin was taken with the women of the region, whose 'Greek beauty' soon began to populate his sketches (fig.12), he found little else to his taste.[19] He took pride in arranging the finances of the household (even factoring in their regular brothel visits), and, back in Paris, Theo sold two of his paintings, but the artists began to argue. Their ways of working – and their tastes – were vastly different. Van Gogh liked to work from nature; Gauguin used his imagination. While van Gogh enjoyed the expressive brushwork of Corot and Théodore Rousseau,

11. Vincent van Gogh
Sunflowers 1888
Oil on canvas
92.1 × 73
National Gallery, London

12. Paul Gauguin
Page from the Huyghe Sketchbook 1888–1901
Pencil and charcoal
on paper
17 × 10.5
The Israel Museum, Jerusalem

for Gauguin the clean lines of Ingres and Raphael won out. Tired of his friend's admiration and criticism, Gauguin sought to leave.

This move would prove too much for van Gogh. A day after throwing a glass of absinthe at Gauguin in the local café, he ran at him with a knife; still in a manic state, he cut off a section of his own ear the following day. Though he remained in contact, Gauguin left Arles and was back in Paris by 27 December. Theo paid for the rental of a studio and Schuffenecker provided him with a place to stay (fig.35). It was not until the summer of 1890 that van Gogh took his own life.

Later, Gauguin would write of the chaos that he had found on arrival in Arles, van Gogh's wildly confused mental state, and his own role in shaping the Dutchman's painting.[20] But during his stay, quite clearly, the creative benefits had been mutual. Together, they had travelled to the Musée Fabre where Gauguin saw Courbet's famous *Bonjour Monsieur Courbet* 1854 (an experience that would later inspire his own variation on the theme; fig.36). And perhaps, through working in such close proximity to such an idiosyncratic artist, he had gained a clearer understanding of his own aims.

Paris 1889

With success still elusive – and funds still scarce – Gauguin began 1889 back in Paris. From the spring, however, the city looked rather different. This was the year of the Exposition Universelle, a large-

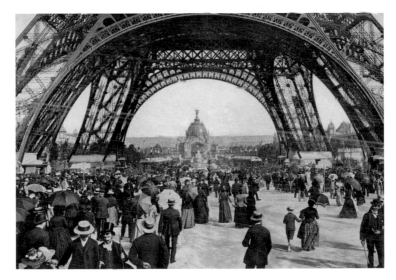

13. Exposition Universelle,
Paris,1889
Private collection

scale celebration of the centenary of the French Revolution, which transformed the centre into a bustling fair (fig.13). Exhibits were numerous and varied: from reconstructions of colonial villages complete with imported inhabitants, to displays of European art and industry, to novelties that included travelators, panoramas and the newly-constructed Eiffel Tower.[21] Gauguin was so taken with the event that he wrote an article on its art displays (his first published piece).[22] Unsurprisingly, he used the occasion to promote ceramics, for he had recommenced work with Chaplet. The disconcerting *Self-Portrait Vase in the Form of a Severed Head* (fig.37), with its glossy rivers of blood-like glaze, is one of a number of pieces that date from this time.

Gauguin also took the opportunity to show his works alongside those of other artists excluded from the official selection in an exhibition at the Café Volpini, within the Exposition site. This was not a designated art space – Theo van Gogh advised Vincent not to participate – but the show convinced a number of young art students that Gauguin was truly progressive. The Nabi movement,

14. Paul Sérusier
The Talisman 1888
Oil on wood
27 × 22
Musée d'Orsay, Paris

inspired by a painting lesson that Gauguin had given to Paul Sérusier in the autumn of 1888 (fig.14), now gathered force. It also encouraged the Dutch painter Jacob Meyer de Haan to befriend the artist. Gauguin depicted him several times over the next few months, on paper, panel or as a carved head. Together they discussed philosophy and religion. In a study for a panel to decorate the inn at Le Pouldu (fig.39), where they would stay in Brittany that autumn, Gauguin painted de Haan beside a lamp, lost in thought, alongside copies of John Milton's *Paradise Lost* and Thomas Carlyle's *Sartor Resartus* (fig.38).

Arguably, though, it was what he saw at the fair, rather than his own role therein, that had a greater impact on Gauguin's future. Its foreign buildings and communities fuelled further dreams of escape. He visited often and made sketches (fig.15). Interestingly, to look at the development of his travel intentions, his choices were to some extent shaped by the Exposition. At first, Gauguin was drawn to Tonkin (Vietnam), which had featured prominently in the grounds with a vast 'palace', before his attention turned to the more 'remote'

15. Paul Gauguin
*Study of people,
'annamites', feet and
heads in profile*
Charcoal on paper
30.5 × 23.5
Musée du Louvre, Paris

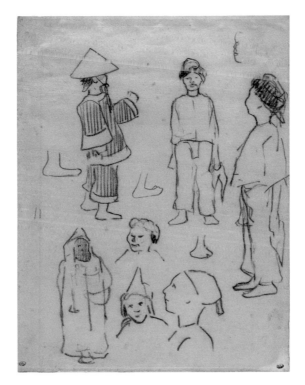

Tahiti, represented only by small huts in a relatively low-key site. This was just as well. Gauguin's attempts to find a government post in Tonkin proved unsuccessful. In 1890, after toying with the idea of going to Madagascar (which he decided was, ultimately, 'too near the civilised world'), he settled on Tahiti,[23] a choice no doubt reaffirmed by more general colonial stereotypes about the island.[24] Europe, as he saw it, had become rotten; but there, 'beneath a winterless sky, on marvelously fertile soil, the Tahitian need only lift up his arms to pick his food…'[25]

Symbolism and the sale

The trip to Tahiti would require funds. Predictably, none were forthcoming. Theo van Gogh was by now in an asylum; Gauguin had no option but to resort to his own commercial wherewithal. At least he had strong works to market. His latest Breton stay had seen him engage more fully with spiritual themes, to powerful effect. New canvases included his 'Yellow' and 'Green' Christs, with their stylised, outlined figures set against dreamlike, undulating hills, both indebted to characteristic regional statuary (figs.40 and 41). He decided to stage an auction of his works and, to this end, he cultivated relationships with influential writers and journalists who could drum up publicity for the sale.

The move was a bold one, and it attracted attention. This shameless networking turned out to be more than his friendship with Pissarro – a committed anarchist – could stand.[26] Schuffenecker had already decided he could no longer live with his former colleague. But Gauguin cared little for the opinions of those who could offer no immediate help. His new champions included the writers Stéphane Mallarmé and Octave Mirbeau. It was perhaps in early 1891, when his writing served Gauguin particularly well, that Mirbeau acquired a preparatory sketch for the major work *The Loss of Virginity* (fig.42).[27] This piece, in which the artist depicted his sometime mistress Juliette Huet together with a symbolic fox and flower, would no doubt have appealed to the intellectuals he now courted so keenly.

Perhaps intentionally, for he knew of its ability to shock, Gauguin chose to include his *Christ in the Garden of Olives* in the sale (fig.43). He encouraged visitors to recognise his self-portrait in this scene of the troubled Saviour, deserted by his companions in a roughly-

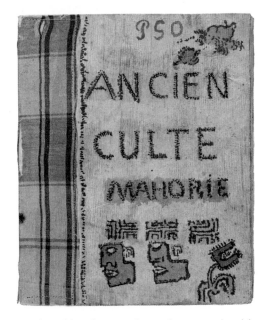

16. Paul Gauguin
Ancien Culte Mahorie
21.4 × 17
Musée du Louvre, Paris

rendered landscape: 'a setting as sad as his soul'.[28] In some respects, however, Gauguin was less alone than ever. The sale raised enough to ensure he could move on and, on 23 March 1891, Mallarmé chaired a well-attended farewell dinner at the Café Voltaire. After Gauguin's departure, a benefit concert took place at the Vaudeville. He left Paris, then, full of pride and optimism. He had even managed to secure some official help for his trip in the form of a reduced fare and a letter that indicated state approval of his wish to capture the character and light of his new island home.

Discovering Tahiti

In July 1891, safely arrived in Tahiti, Gauguin wrote a heartfelt letter to Metto. The impression it gives is one of excitement and wonder. He explained how the silence of the place overwhelmed him and that he felt at rest. He expressed his admiration for the beauty of the people, their relaxed attitude to life, their honesty and integrity. 'And they are called savages?', he pondered, as if facing the prejudices of the age face on. He was quick, however, to assure his wife that his stay was temporary. 'But let me live like this for a while,' he reasoned. 'Those who heap blame on me don't know everything there is in an artist's innermost being.'[29]

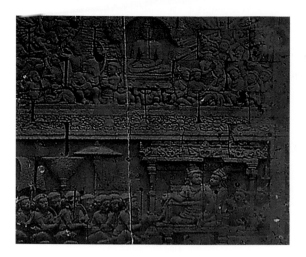

17. Bas relief from Borobudur Temple, Indonesia
Tahiti Museum

However, in this supposed paradise, things were not completely idyllic. French rule dominated late nineteenth-century Tahiti; church-going had replaced traditional religion and mythology.[30] And Gauguin disappointed the colonial population of the capital, Papeete. They had taken his official status as an indication that he might produce works to their taste, but his *Portrait of Susan Bambridge* (fig.44) failed to please its English sitter.

Faced with this dilemma, he moved further afield and turned to his inner resources. It is likely that some of his landscapes from this period show the area around Mataiea, the small village in which he chose to settle. But he used poses taken from other sources for his figures (the horseman, here, recalls types seen in classical relief sculpture) and added 'exotic' titles (often misspelt or without any clear sense) to provide an element of mystery (figs.45 and 46).

Hence, once again, Gauguin's behaviour appears contradictory. He had a genuine interest in indigenous culture and took almost a year to begin to 'grasp the oceanic character'.[31] He kept a notebook, entitled *Ancien Culte Mahorie* (fig.16), in which he elaborated on the rituals and legends described in a Belgian study of Oceanic life that he had borrowed from a fellow expat. But he also sought visions that would satisfy his preconceived ideas. The original title of his *Parahi Te Marae* (fig.47), for instance, alluded to the legend of child sacrifice associated with the place it mentioned. Yet his scene included an Easter Island-esque statue and a fence patterned with a non-

Tahitian Maori design. The myth, here, is very much Gauguin's own. In other works he made use of photographs, or of objects he had seen elsewhere. His *Shell Idol* (fig.48), for example, which is remarkable for its use of mixed media (the teeth are taken from a parrotfish), seems to depict the Tahitian god Ta'aroa. But the pose of the cross-legged idol, taken from one of Gauguin's photographs, is from a bas-relief at Borobudur (fig.17).[32] However knowledgeable he might have been about the places and people he depicted, ultimately he was an artist rather than an anthropologist.[33]

Soon Gauguin became taken with the idea of finding the essence of the country in femininity.[34] In his account of his Tahitian experience, *Noa Noa*, which he began to write in 1893, Gauguin made much of his encounters with native women.[35] Tales ranged from his dissatisfaction with his first *Vahine*, Titi, who was half white and too well used to European visitors for his taste, to his joy at painting the *Tahitian Woman with Flower* (fig.49).[36] In another episode, he even explained his wish to be 'the weaker being, who loves and obeys', as he told of his suppressed homosexual desire for an androgynous young friend.

Often, in somewhat generic depictions, Gauguin presented Tahitian women as an extension of nature, as available as the fruit and flowers in their hands (fig.50). His most important encounter, however, was more complex. His marriage to the thirteen-year-old Tahitian Teha'amana, a 'tall child' who 'displayed the proud independence of the entire race', was suggested by her family (her birth and adoptive parents alike; fig.51). Gauguin recounted their tentative beginnings, their jealousy, how each learnt about the culture of the other… He put forward a narrative to connect with his *Manao Tupapaü*: a story of his returning late from the city, to find Teha'amana lying on their bed, afraid and mistrustful. The subject of the image is at once the girl's fear of the strange watching figure and her nubile, 'marvellous', body, angled out towards the viewer (fig.52). Many of his other works from this period refer to human relationships and feelings – envy, marriage, curiosity (figs.53-5) – inviting parallels between European and Tahitian experience and underlining a range of cultural difference.

In *Noa Noa*, the artist claimed that family ties called him back to France in 1893. It is true that, despite his bigamy and another illegitimate child in Paris, he still thought his marriage might be salvaged. But there were other concerns. Works had been sold

18. Paul Gauguin
Manao Tupapaü (Watched by the Spirits of the Dead)
1893–4
Woodcut
20.4 × 35.5
British Museum, London

19. Paul Gauguin and friends with Anna 'La Javanaise', 1894–5
Private collection

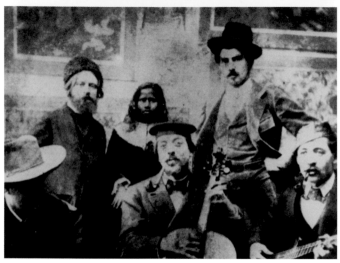

in Paris in 1892, without Gauguin receiving payment, and he had neglected his health for want of money. He left Tahiti in June, with sixty-six paintings, several sculptures, and hopes of sales that would bring financial security.

Soon after his return to Paris, Gauguin persuaded the art dealer Paul Durand-Ruel to mount an exhibition of his work. He was confident enough to agree to cover the associated costs. But though Degas bought two pictures, and journalists praised the exhibition, the event was a commercial failure. Gauguin decided that a lack of understanding was to blame. He approached Charles Morice with a view to working together on *Noa Noa*, but the project was ill-fated. Morice delayed the process, changed the text, and

nothing materialised until 1901. The only immediate gain afforded by the project, as demonstrated by the bold design of *Manao Tupapaü* (fig.18), was an opportunity to experiment with print-making techniques.

Gauguin also found a new model (and mistress) in the capital. Despite her Indian and Malay origins, Anna 'the Javanaise' posed for further Tahitian works: proof again that Gauguin was happy to combine references quite freely (fig.19). However, though a suitably 'exotic' companion for a bohemian, Anna pillaged his studio while Gauguin was in Pont-Aven in the autumn of 1894. Ill and relatively friendless – but fortunate enough to have received a windfall inheritance – he decided to leave France once more. His destination of choice: the Marquesas.

Endings and beginnings

Gauguin left Europe for the last time in 1895. En route, on an obligatory stop in New Zealand, he took the opportunity to visit the Auckland Institute and Museum. Its new ethnographic hall purported to illustrate 'the habits and mode of life of the Maori race' and Gauguin made sketches of some of the exhibits to use in later works. A 'kumete' from the 1870s a carved presentation bowl incorporating two figure supports – would feature in his *Still Life with Sunflowers and Mangoes* (fig.56), while Pukaki, a gateway warrior figure, dominates the background of *The Great Buddha* (fig.20).[37]

The latter canvas offers a particularly important insight into this moment in Gauguin's career. Delayed in his plans to travel onwards (he was now in the advanced stages of syphilis and could not be far from a hospital), Gauguin remained in Tahiti where his habitual recourse to imagination and visual memory became more necessary than ever. The alluring female figure in *Te arii vahine*, who reclines languidly in her Arcadian surrounds, belongs firmly to the European tradition of painted nudes (fig.57), while his *Nevermore* (fig.58) harks back to a poem by Edgar Allen Poe. But the combination of a Maori idol and Buddhist temple architecture in *The Great Buddha* also reflects the evolution of Gauguin's ideas on religion in the late 1890s. He had begun to write on spirituality – an undertaking that would culminate in his *L'esprit moderne et le catholicisme* of 1902 – and this is reflected in several of his painted works (fig.59).[38]

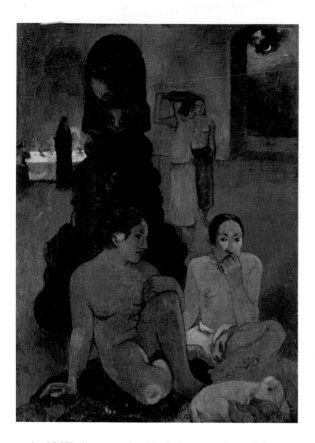

20. Paul Gauguin
The Great Buddha 1899
Oil on canvas
134 × 95
State Pushkin Museum of
Fine Arts, Moscow

In 1897, due to a double inflammation of the conjunctiva, Gauguin
was forced to spend hours prostrate in bed. The contemplation that
ensued must have been painful: at around the same time, he had
learnt of the premature death of Aline, his favourite daughter, for
whom he had compiled a special scrapbook (Mette's letter to break
the news, and Gauguin's reply, saw an end to their correspondence).
In August, exhausted both physically and emotionally, he seemed at
odds with the world. 'Ever since my infancy misfortune has followed
me,' he complained. 'Never any luck, never any joy. Everyone against
me, and I exclaim: God Almighty, if You exist, I charge You with
injustice and spitefulness.'[39]

Above all, surely, Gauguin was mindful of mortality. In the winter
of 1896, his latest mistress, Pahura, had given birth to a child that died
soon afterwards. And in December 1897, after having suffered from
a heart attack, he set to work on an ambitious mural composition

– Where Do We Come From? What Are We? Where Are We Going? (fig.60) – that questioned the meaning of existence.[40] On its completion, after a month of obsessive work, he attempted to take his own life.

Yet ironically, as the artist thought of death, his art began to take on a new life in Paris. The young art dealer Ambroise Vollard had started to take an interest in his work.[41] Admittedly, Vollard controlled prices and withheld monies from the artist; but he did bring Gauguin's work to the attention of an emerging avant-garde.

Conclusion

In 1901, crippled by healthcare costs and forced to sell his Tahitian studio, Gauguin moved to the Marquesas. He was welcomed by the locals and the Bishop sold him a piece of land, placed between the Catholic and Protestant churches (a transaction facilitated by his attendance at mass). But these friendly relations soured. Gauguin persuaded a tribal chief to let his daughter leave school and become his *Vahine*. She fell pregnant shortly afterwards. He refused to pay his taxes too, and found himself in a stressful legal battle. Before long, the Bishop set about ensuring others would not meet the moral fate of Gauguin's young lover. In response, Gauguin made sculpted caricatures of him and his housekeeper, which he displayed outside his house. At the time of his death, accused of slander against the authorities, the artist was threatened with imprisonment.

Yet the artist's final home itself, 'La maison de jouir' (The House of Pleasure), was constructed with the help of his neighbours. Its main decorations – a series of large carved panels (fig.21) – reveal no adversity. When Ségalen found them on his discovery of the late artist's studio, he arranged to ship them to Paris. Their message of sexual pleasure and mystery, their curious combination of imagery and their distinctive tactile surfaces, must have seemed stranger to him than the Marquesas themselves. Most significantly, if Gauguin was set apart from his adopted community, he was also unlike other colonial visitors.

21. Paul Gauguin
Maison du Jouir (detail)
1902
Carved wooden panels
Musée d'Orsay, Paris

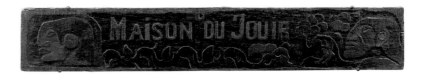

22
The Artist's Mother
1890/1894
Oil on canvas
41 × 33
Staatsgalerie Stuttgart

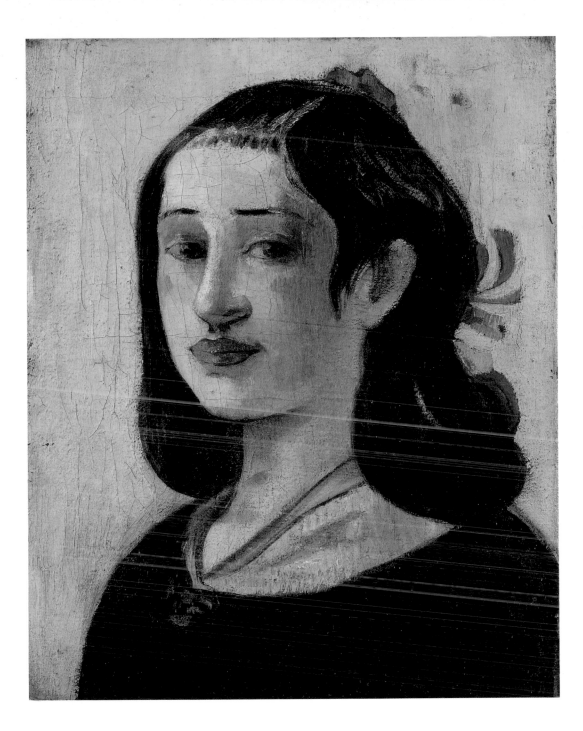

23
Portrait of Mette Gauguin
1877
Marble
34 × 26.5 × 18.5
The Courtauld Gallery,
London

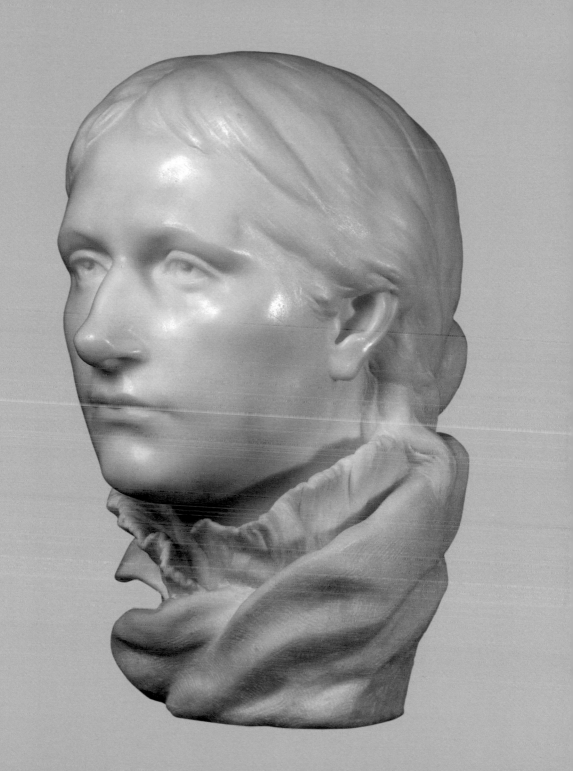

24
Blue Roofs, Rouen 1884
Oil on canvas
74 × 60
Collection Oskar Reinhart
– Am Römerholz –
Winterhur

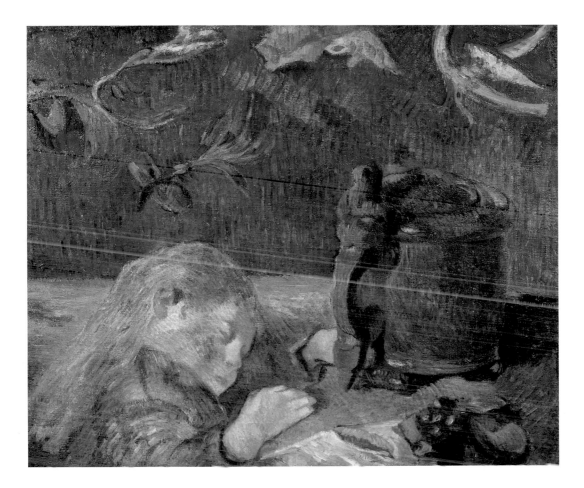

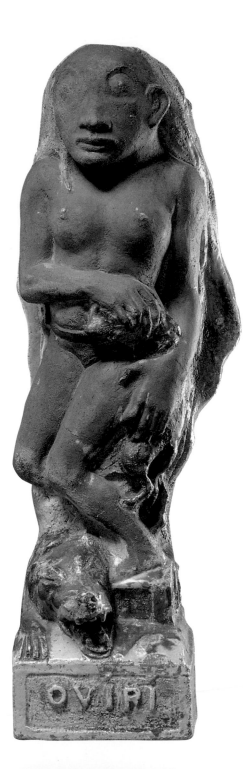

26
Oviri 1894
Stoneware
Height: 75
Musée d'Orsay, Paris

27
*Vase decorated with
Breton scenes* 1886–7
Ceramic
Musées Royaux d'Art et
d'Histoire, Brussels

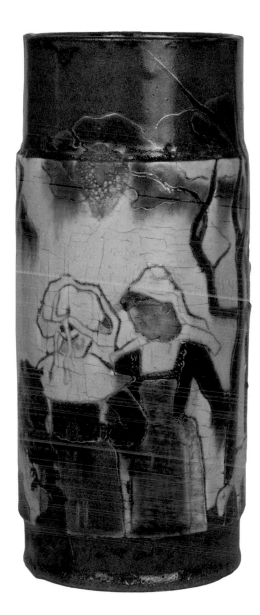

28
*Still Life with Profile of
Laval* 1886
Oil on canvas
47.5 × 39.5
Indianapolis Museum
of Art

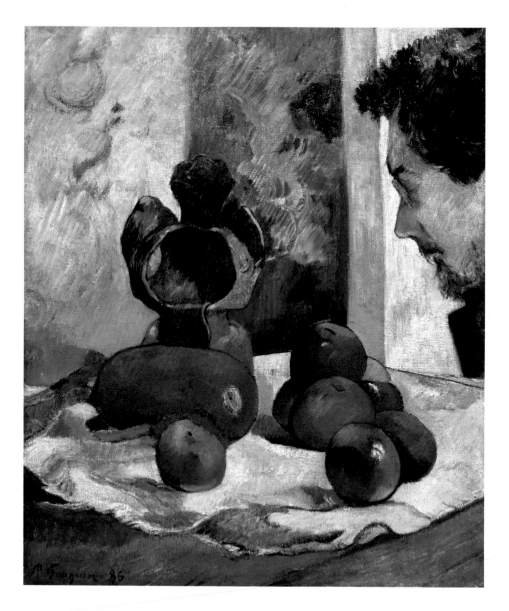

29
Coming and Going,
Martinique 1887
Oil on canvas
72.5 × 92
Museo Thyssen-
Bornemisza, Madrid

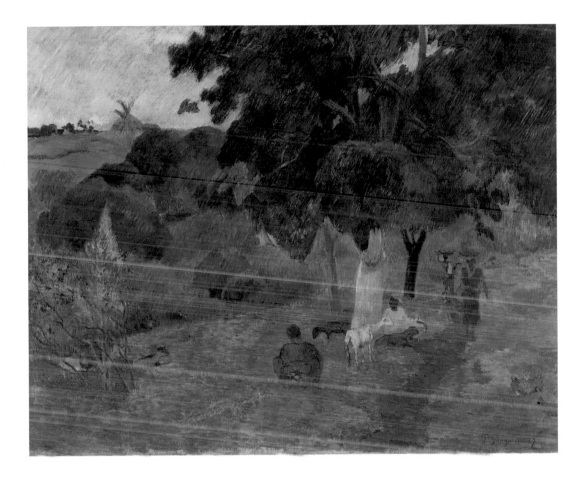

30
Bather in Brittany 1887
Oil on canvas
87.5 × 69.5
Museo Nacional de Bellas
Artes, Buenos Aires

31
Ondine (In the Waves)
1889
Oil on canvas
92.5 × 72.4
The Cleveland Museum
of Art

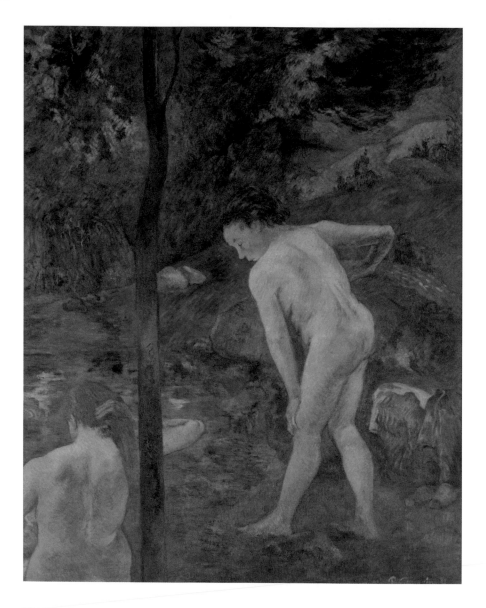

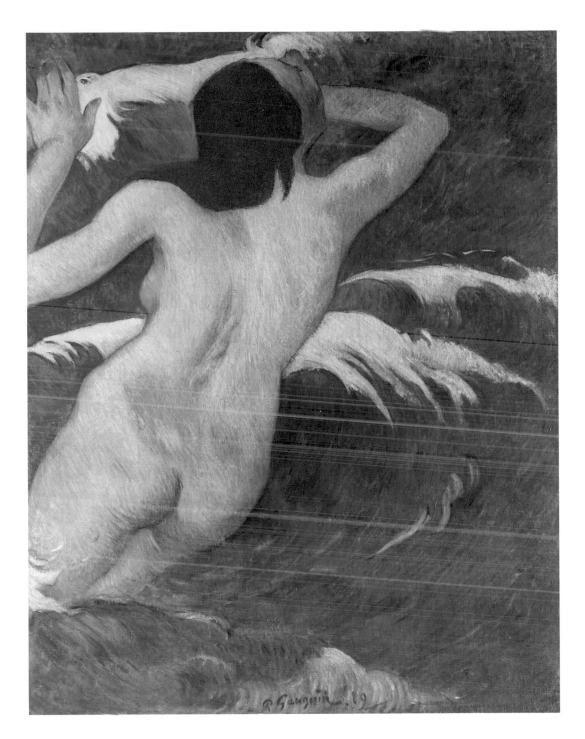

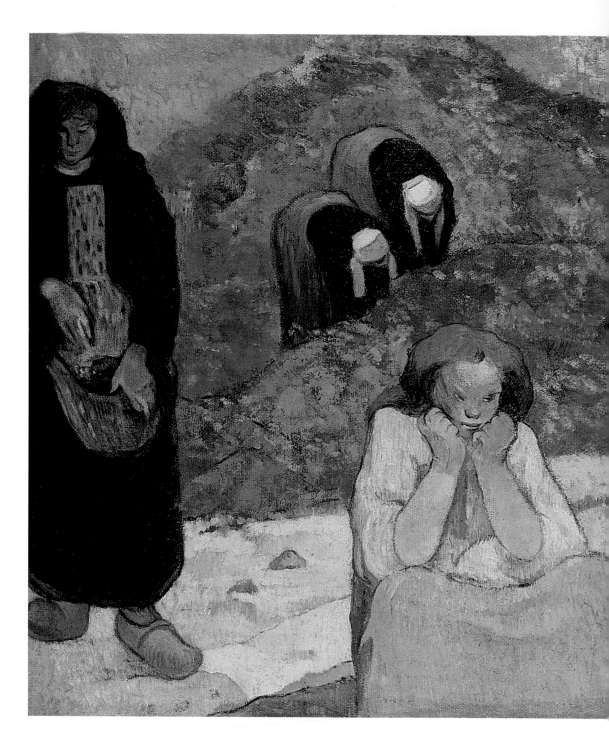

32
*The Wine Harvest at Arles
(Misères Humaines)* 1888
Oil on burlap
73 × 92
The Ordrupgaard
Collection, Copenhagen

33
*Vision of the Sermon
(Jacob Wrestling with
the Angel)* 1888
Oil on canvas
72 × 91
National Galleries Scotland

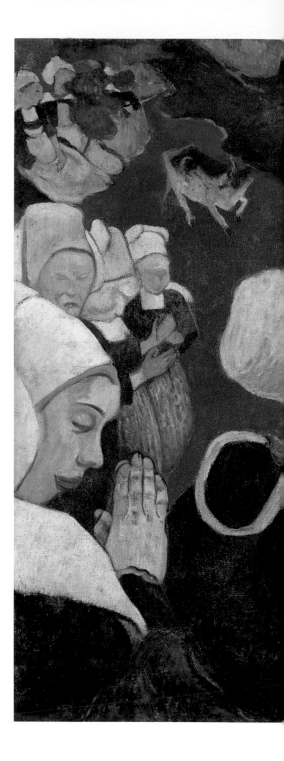

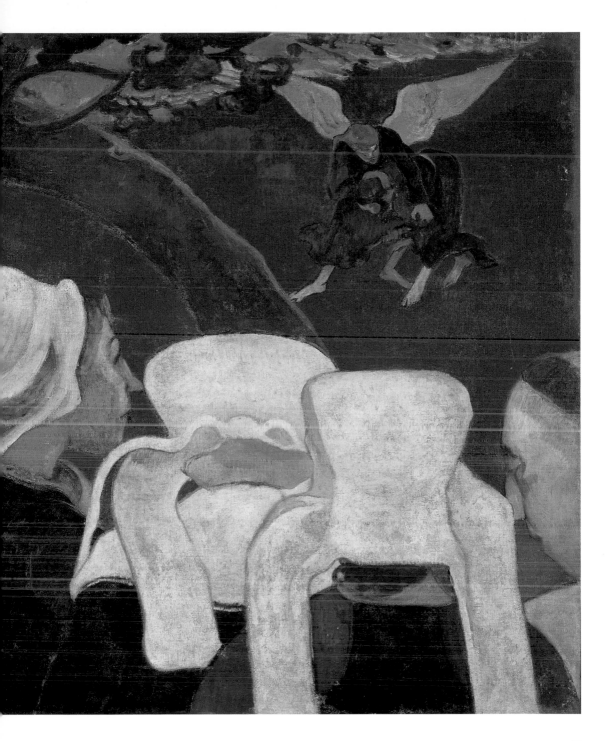

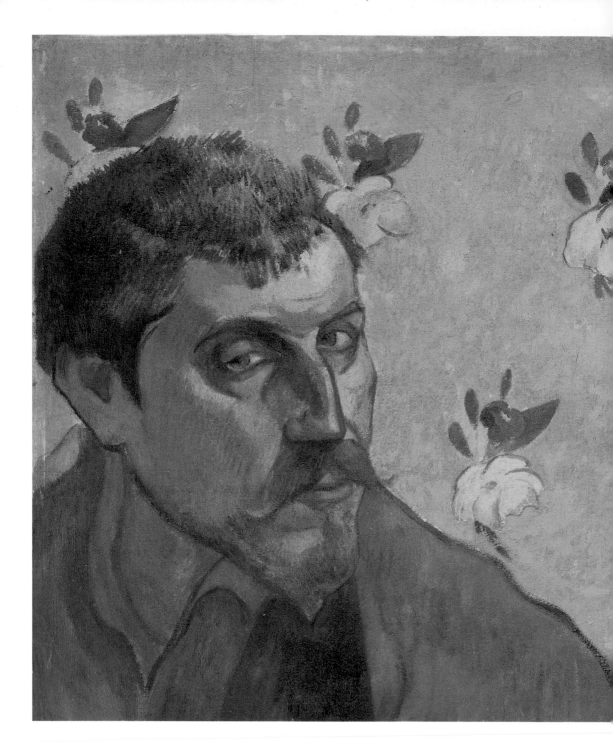

44

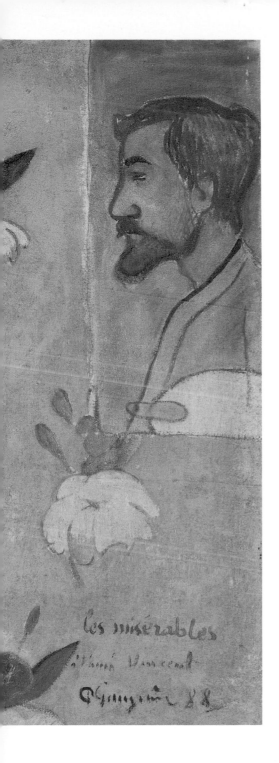

34
Self-Portrait with Portrait of Bernard 1888
Oil on canvas
45 × 55
Van Gogh Museum,
Amsterdam (Vincent
van Gogh Foundation)

35
The Schuffenecker Family
1889
Oil on canvas
73 × 92
Musée d'Orsay, Paris

36
Good Morning,
Mr Gauguin 1889
Oil on canvas
75 × 55
Hammer Museum,
Los Angeles

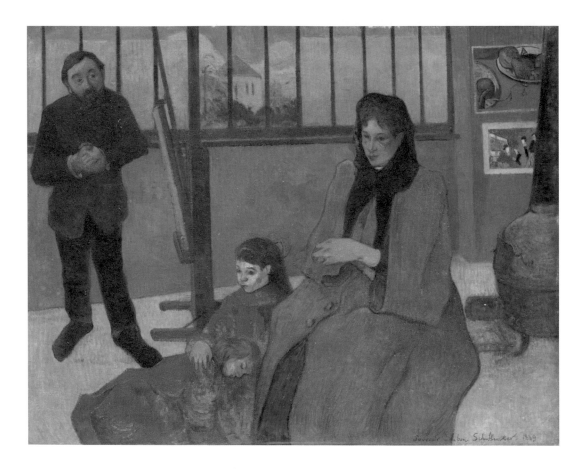

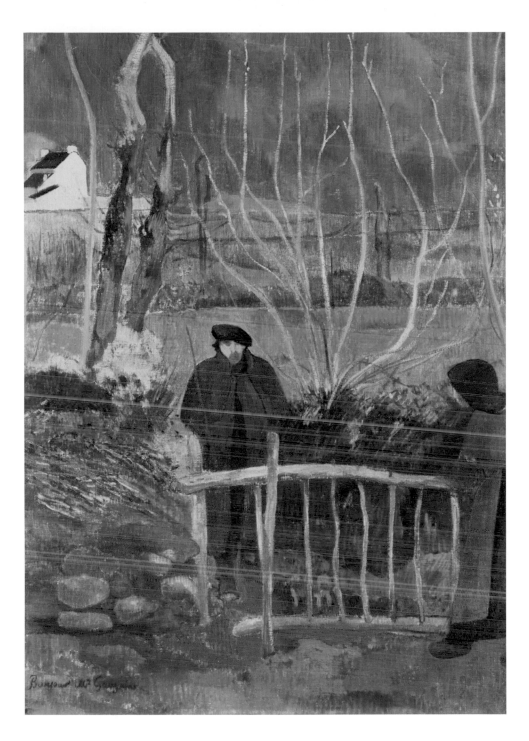

3 /
Self-Portrait Vase in the
Form of a Severed Head
1889
Stoneware
Height: 19.3
The Ordrupgaard
Collection, Copenhagen

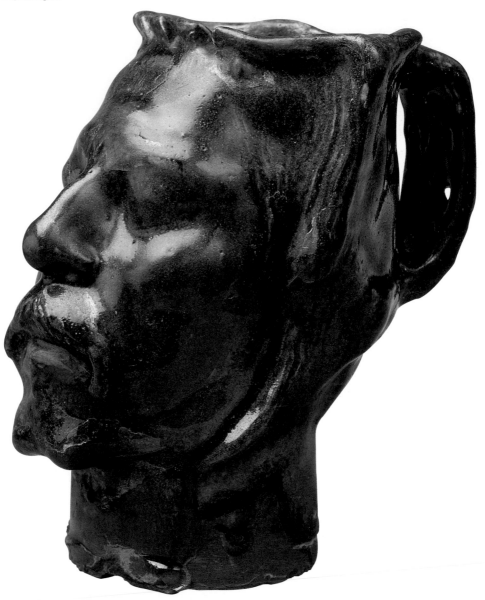

38
*Portrait of Jacob Meyer
de Haan* 1889
Watercolour and pencil
on paper
16.2 × 11.4
The Museum of Modern
Art, New York

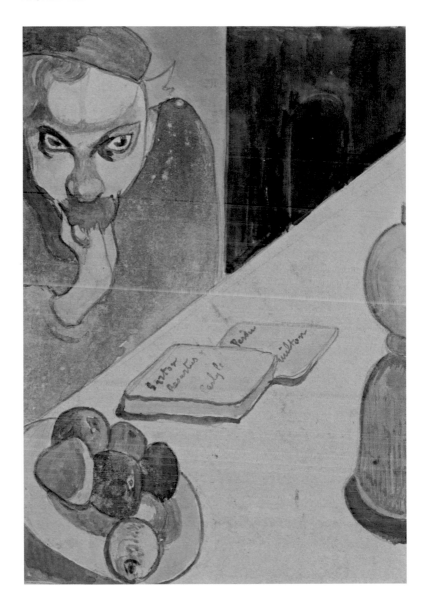

39
Harvest, Le Pouldu 1890
Oil on canvas
73 × 92.1
Tate

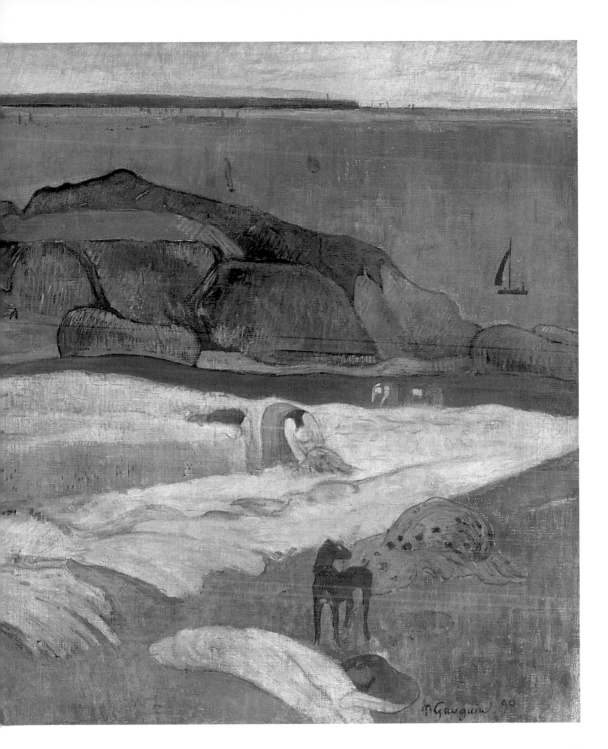

40
The Green Christ 1889
Oil on canvas
92 × 73.5
Royal Museums of Fine
Arts of Belgium, Brussels

41
The Yellow Christ 1889
Oil on canvas
92 × 73.3
Albright-Knox Art Gallery,
Buffalo

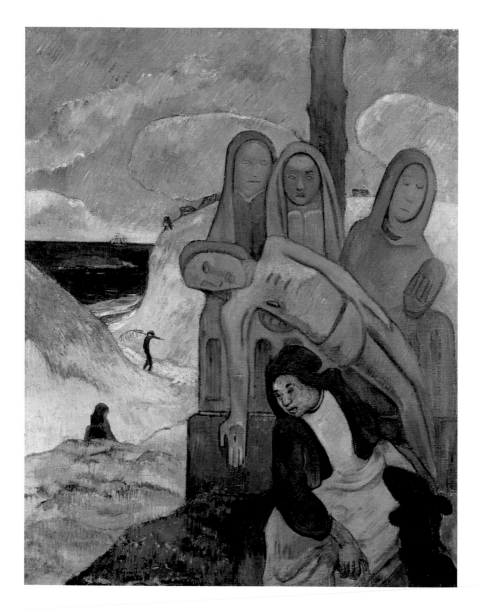

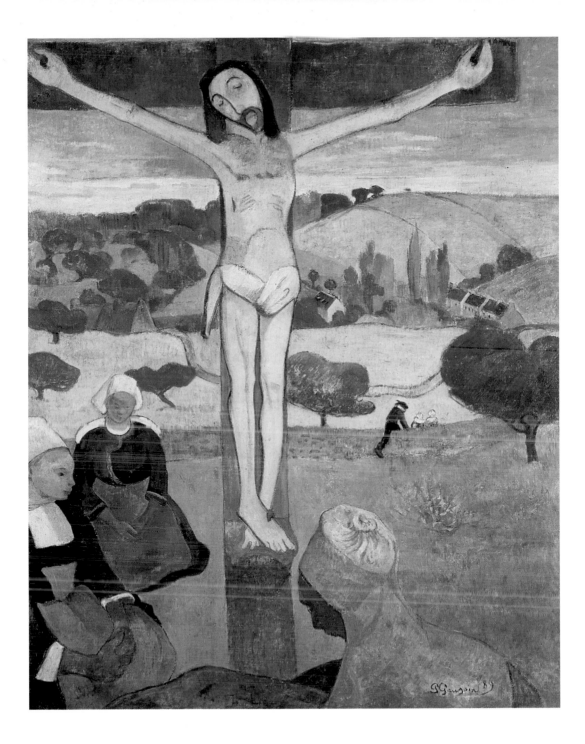

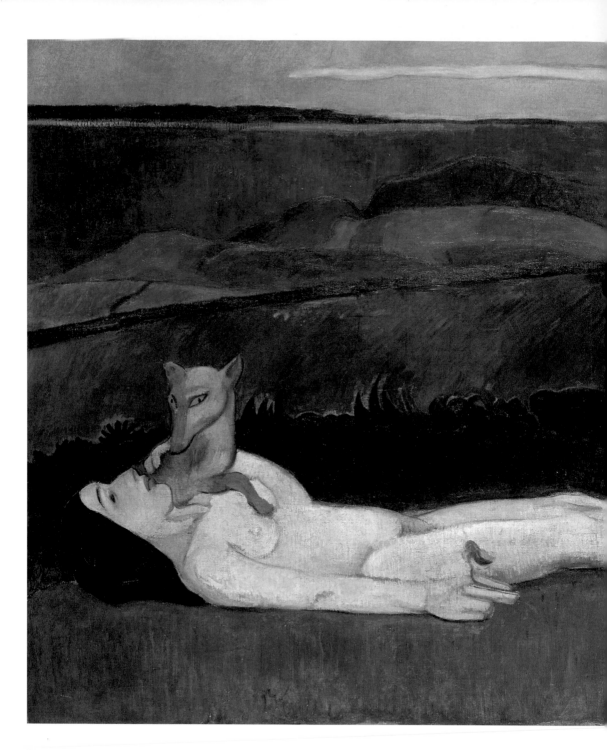

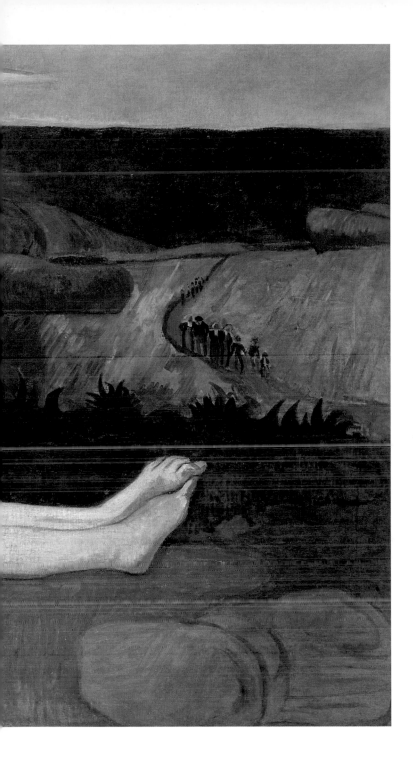

42
The Loss of Virginity
1890–1
Oil on canvas
89.5 × 130.2
Chrysler Museum of Art,
Virginia

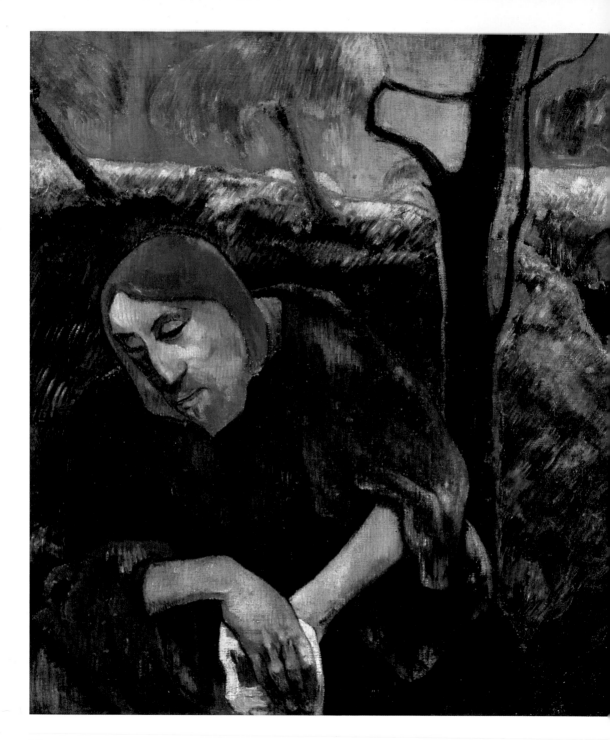

43
*Christic in the Garden
of Olives* 1889
Oil on canvas
73 × 92
Norton Museum of Art,
Florida

44
*Portrait of Susan
Bambridge* 1891
Oil on canvas
70 × 50
Royal Museums of Fine
Arts of Belgium, Brussels

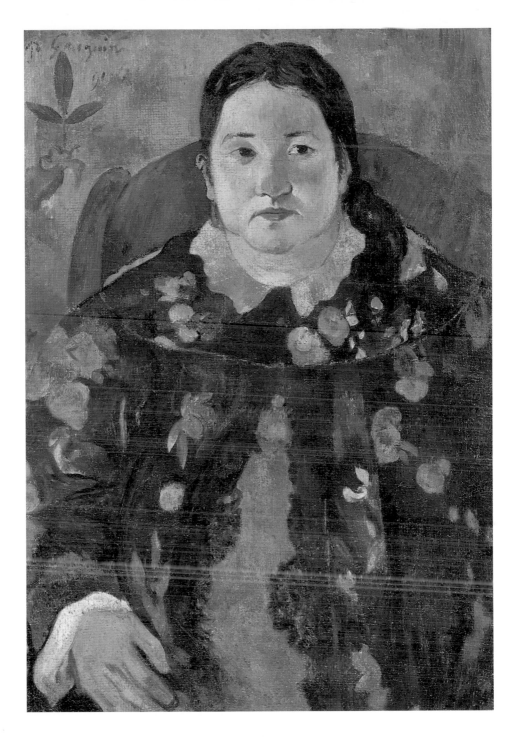

45
Haere Mai 1891
Oil on burlap
72.4 × 91.4
Solomon R. Guggenheim
Museum, New York

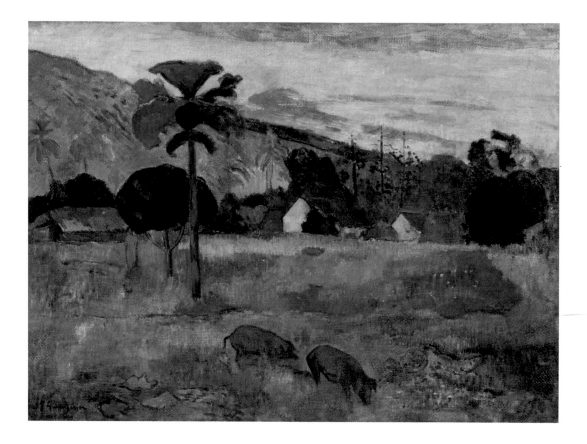

46
In the Vanilla Grove,
Man and Horse 1891
Oil on burlap
73 × 92
Solomon R. Guggenheim
Museum, New York

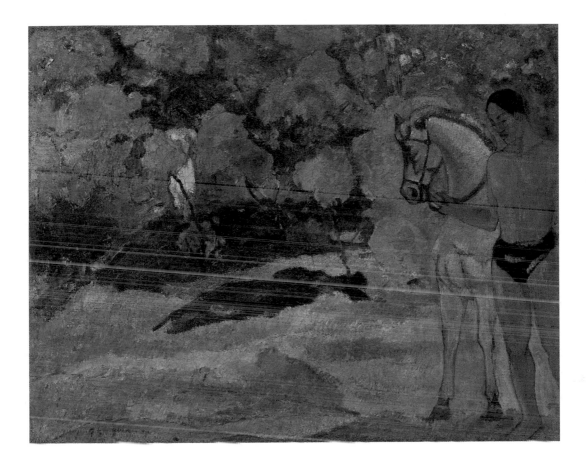

47
Sacred Mountain
(Parahi Te Marae) 1892
Oil on canvas
66 × 88.9
Philadelphia Museum
of Art

48
Shell Idol 1892
Wood, shell and ivory
Height: 34.4
Musée d'Orsay, Paris

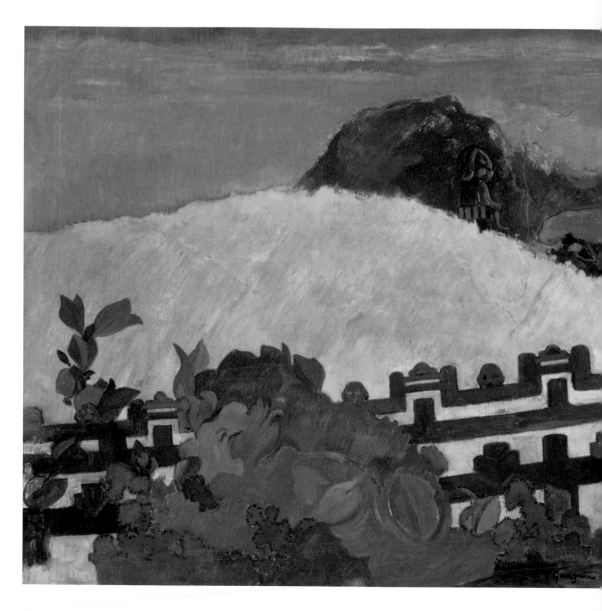

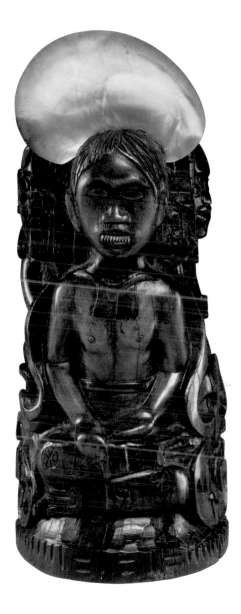

49
Tahitian Woman with Flower 1891
Oil on canvas
70.5 × 46.5
Ny Carlsberg Glyptotek, Copenhagen

50
Two Tahitian Women 1899
Oil on canvas
94 × 72.4
The Metropolitan Museum of Art, New York

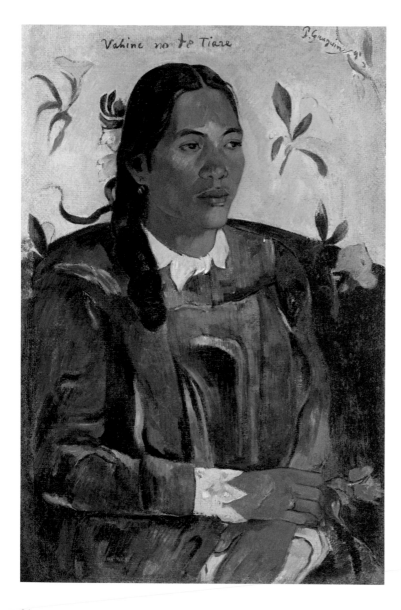

Vahine no te Tiare

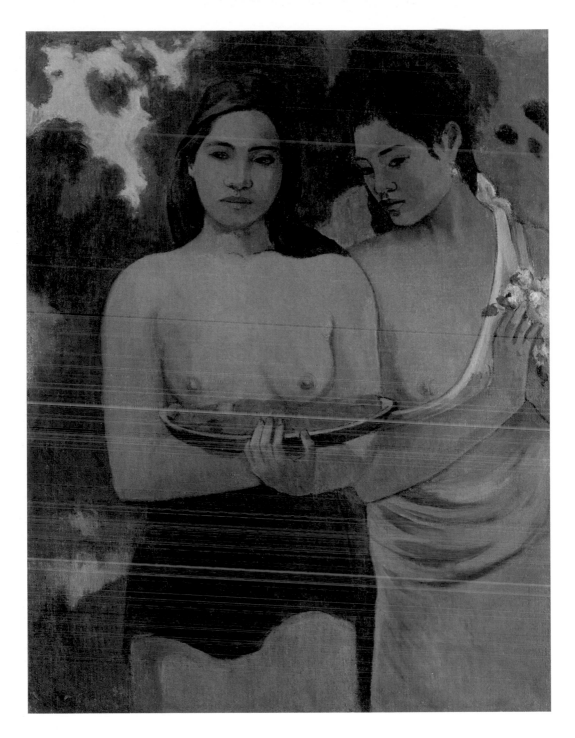

65

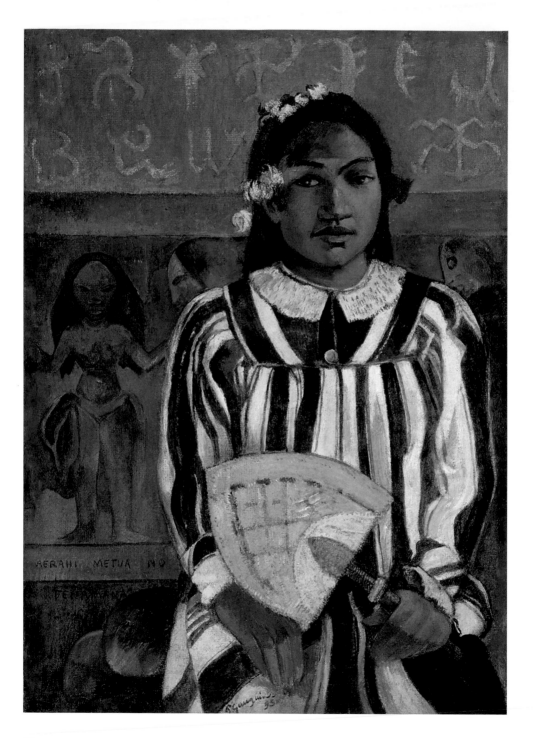

51
*Teha'amana Has Many
Parents* 1893
Oil on canvas
76.3 × 54.3
The Art Institute Chicago

52
*Manao Tupapaü (Spirit of
the Dead Watching)* 1892
Oil on burlap mounted
on canvas
72.4 x 97.5
Albright-Knox Art Gallery,
Buffalo

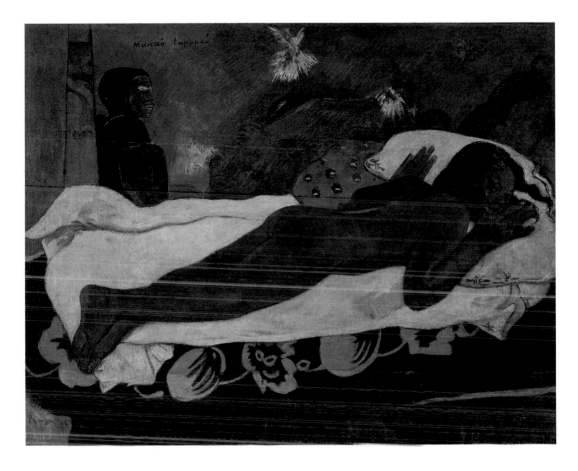

53
Aha oe Feii? (What! Are You Jealous?) 1892
Oil on canvas
66 × 89
State Pushkin Museum
of Fine Arts, Moscow

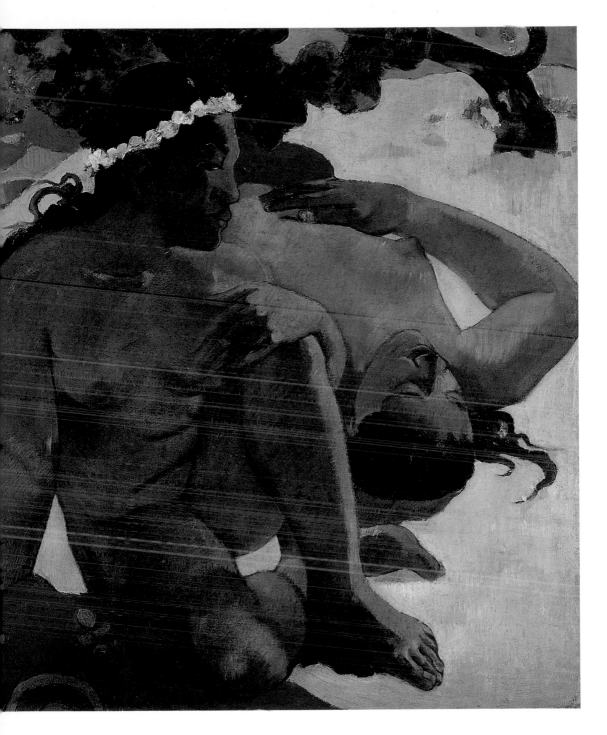

54
Eu haere ia oe (Where Are You Going?) 1893
Oil on canvas
92.5 × 73.5
The State Hermitage Museum, St Petersburg

55
Nafea faaipoipo (When Will You Marry?) 1892
Oil on canvas
101.5 × 77.5
Kunstmuseum Basel

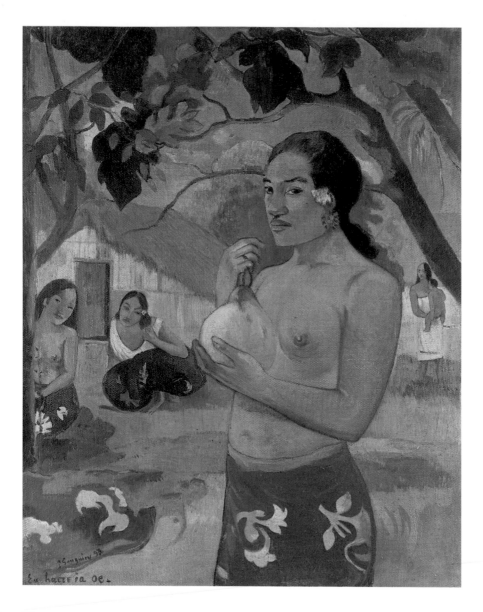

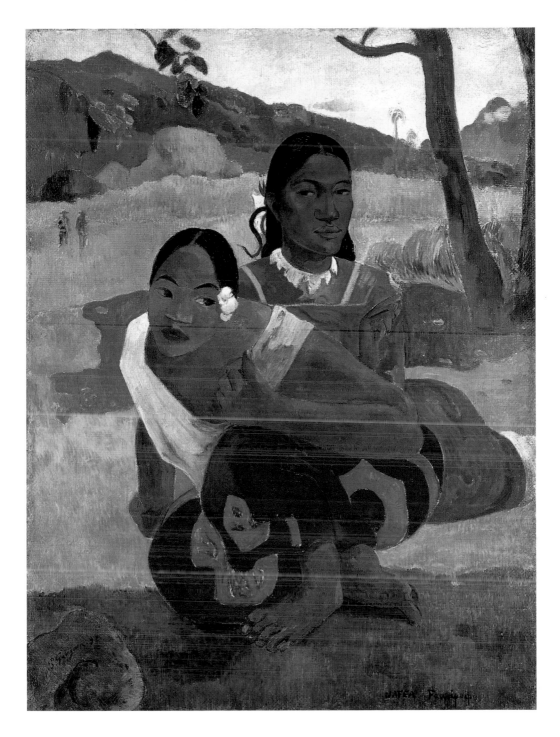

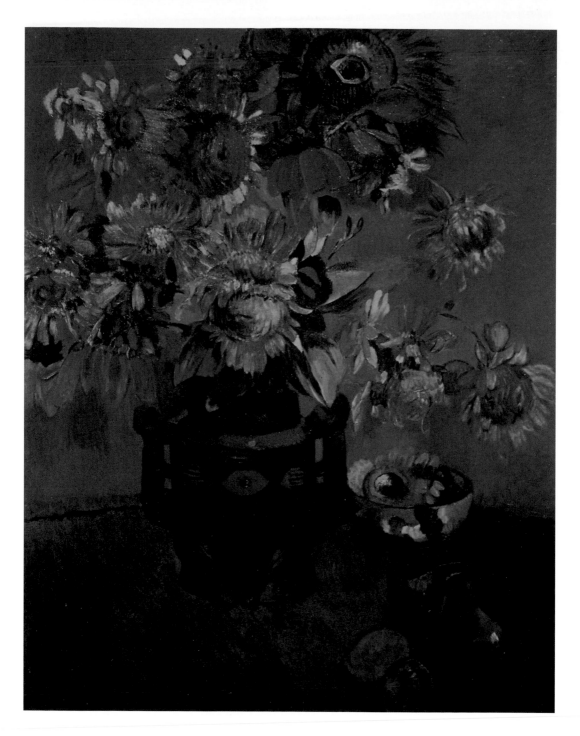

56
Still Life with Sunflowers and Mangoes 1901
Oil on canvas
93 × 73
Private collection

57
Te arii vahine (The King's Wife) 1896
Oil on canvas
97 × 128
State Pushkin Museum of Fine Art, Moscow

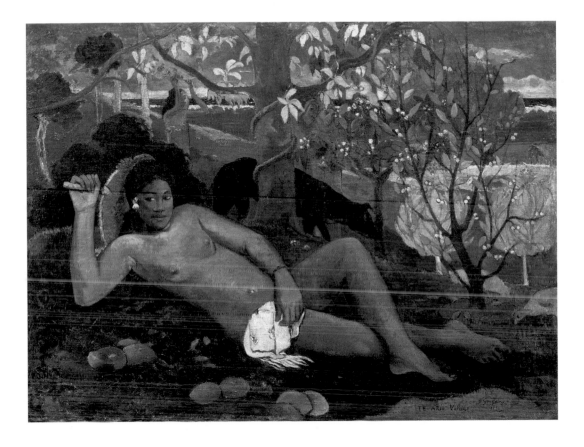

58
Nevermore 1897
Oil on canvas
60.5 × 116
The Courtauld Gallery,
London

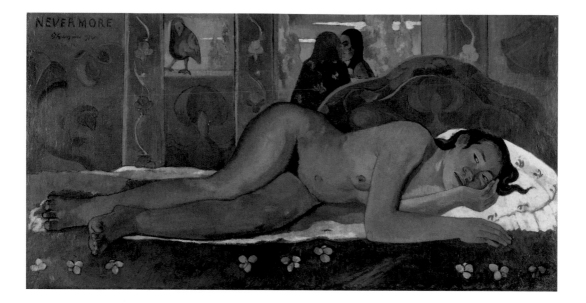

59
Bebe / Nativity 1896
Oil on canvas
67 × 76.5
The State Hermitage
Museum, St Petersburg

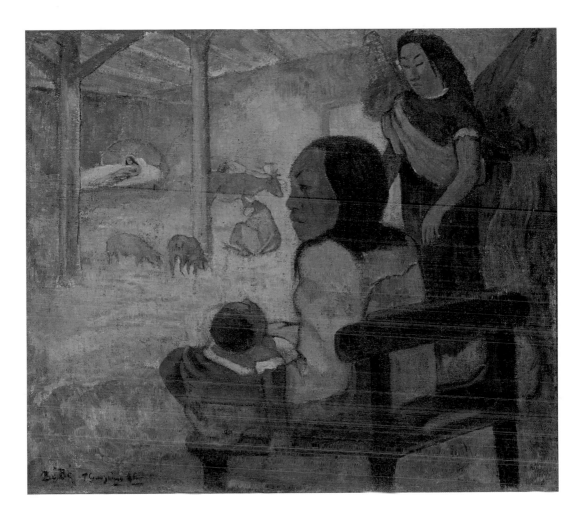

60
Where Do We Come From?
What Are We? Where Are
We Going? 1897–8
Oil on canvas
139.1 × 374.6
Museum of Fine Arts, Boston

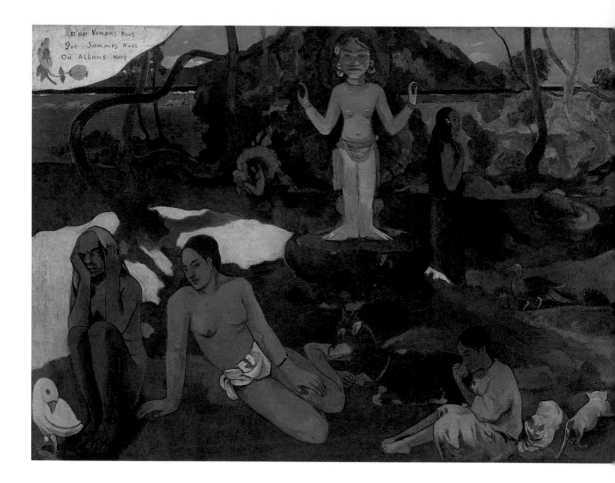

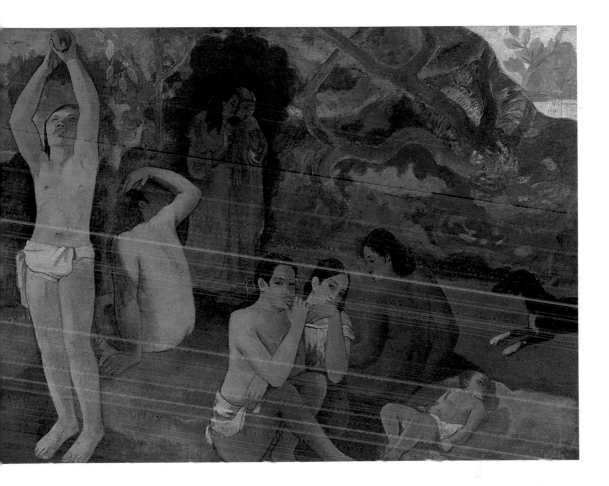

Notes

1. Victor Ségalen, *Gauguin dans son dernier décor et autres textes de Tahiti*, eds. Joly Ségalen and Dominique Lelong, Montpellier 1975, p.24.

2. For more on the Ségalen–Gauguin connection see Charles Forsdick, 'Gauguin and Ségalen: Exoticism, Myth and "Aesthetics of Diversity"' in Belinda Thomson (ed.), *Gauguin: Maker of Myth*, exh. cat., Tate, London 2010.

3. Paul Gauguin, letter to Emil Schuffenecker, late December 1888, Arles in Paul Gauguin, *Writings of a Savage*, ed. Daniel Guérin, trans. Eleanor Levieux, New York 1978, p.28.

4. Victor Merlhès, *De Bretagne en Polynésie: Paul Gauguin, pages inédites*, Paris 1995, p.8.

5. Letter dated 25 January 1882. Paul Gauguin, *Correspondence de Paul Gauguin, 1878–1888*, vol.1, ed. Victor Merlhès, Paris 1984, p.22.

6. Letter dated c.May–June 1882 in ibid., p.29.

7. Henry Perruchot, *Gauguin*, trans. Humphrey Hare, London 1963, p.79.

8. For more on this work see Anne Pingeot, 'Oviri' in *Gauguin/Tahiti: l'atelier des tropiques*, exh. cat., Musée d'Orsay, Paris 2003, pp.187–96.

9. This myth prevailed until the 1980s; only then was it carefully deconstructed by Griselda Pollock and Fred Orton, 'Les données Bretonnantes: La prairie de représentation', *Art History*, vol.3, no.3, London 1980, pp.314–44.

10. François Cadic, *Les Bretons: considérations sur leur passé et leur situation présente*, Paris 1902, chapter 3. He describes the Bretons as 'les peuples apôtres … le bon grain qui fait germer les opulentes moissons. De ceux-là est le peuple français.'

11. Philippe Dagen, *Le peintre, le poete, le sauvage*, Paris 1998, p.95.

12. Letters from Gauguin to Mette, early May 1887, Panama and 20 June 1887, St-Pierre, Martinique in Gauguin 1978, pp.19–21.

13. Letter from Gauguin to Mette, early May 1887 in ibid., p.19.

14. For a detailed discussion of Gauguin's stay in Martinique in relation to race see Tamar Garb, 'Gauguin and the Opacity of the Other: The Case of Martinique' in Thomson 2010.

15. Letter from Gauguin to Schuffenecker, February 1888, Pont-Aven in Gauguin 1978, p.23.

16. For a detailed discussion of the significance of these canvases and Gauguin's stay in Brittany see Belinda Thomson, Frances Fowle and Lesley Stevenson, *Gauguin's Vision*, exh. cat., National Galleries of Scotland, Edinburgh 2005.

17. On religion and art in late nineteenth-century France see Richard Thomson, *The Troubled Republic: Visual Culture and Social Debate in France 1889–1900*, New Haven and London 2004, pp.117–67.

18. Paul Gauguin, letter to Schuffenecker, 8 October 1888, Quimperlé in Gauguin 1978, p.25.

19. Paul Gauguin, letter to Emile Bernard, December 1888, Arles in ibid., p.27.

20. Paul Gauguin, *Avant et après*, preface by Jean-Marie Dallet, Paris 1994, pp.21–32.

21. For more information on the exhibits and layout see *1889: la tour Eiffel et l'Exposition Universelle*, exh. cat., Musée d'Orsay, Paris 1989.

22. Paul Gauguin, 'Notes on Art at the Universal Exhibition', *Le Moderniste illustré*, 4 and 11 July 1889, reproduced in Gauguin 1978, pp.30–4.

23. Paul Gauguin, letter to Odilon Redon, September 1890 in ibid., p.43.

24. For more on this see Vincent Gille, 'The Last of Orientalist: Portrait of the Artist as Mohican' in Thomson 2010.

25. Paul Gauguin, letter to J.F. Williamson, Brittany, late 1890 in Gauguin 1978, p.46.

26. For more on Gauguin's politics see Philippe Dagen, 'Gauguin's Politics', in Thomson 2010.

27. On this connection see Denys Sutton, '*La perte de pucelage* by Paul Gauguin', *Burlington Magazine*, vol.91, no.553, April 1949, pp.103–5.

28. Paul Gauguin, as quoted in an interview by Jules Huret, *L'Echo de Paris*, 23 February 1891, reproduced in Gauguin 1978, pp.49–50.

29. Ibid., pp.54–5.

30. For a revisionist reading of Gauguin's Tahitian experience see Abigail Solomon-Godeau, 'Going Native: Paul Gauguin and the Invention of Primitivist Modernism' in Norma Broude and Mary D. Garard (eds.), *The Expanding Discourse: Feminism and Art History*, Boulder and Oxford 1992, pp.313–29.

31. Paul Gauguin, letter to Mette, June 1892, Tahiti in Gauguin 1978, p.59.

32. On Gauguin's sculpture during his first visit to Tahiti see Anne Pingeot, 'Premier séjour à Tahiti, 1891–1893, la sculpture' in *Gauguin/Tahiti: l'atelier des tropiques* 2003, pp.104–24.

33. For a revisionist interpretation of Gauguin's relationship to Tahitian culture see Stephen F. Eisenman, *Gauguin's Skirt*, London 1999.

34. Peter Brooks, 'Gauguin's Tahitian Body', in Broude and Garard 1992, pp.381–45. On Pierre Loti (1850–1923), one of the novelists whose experiences and writings invite the strongest comparison with those of Gauguin, see Belinda Thomson, 'Paul Gauguin: Navigating the Myth' in Thomson 2010.

35. For an introduction to *Noa Noa* and Gauguin's other writings see Linda Goddard, '"Following the Moon": Gauguin's Writing and the Myth of the "Primitive"', in Thomson 2010.

36. Paul Gauguin, 'Noa Noa', excerpts reproduced in Gauguin 1978, pp.76–102.

37. On Gauguin in Auckland see Bronwen Nicholson et al., *Gauguin and Maori Art*, exh. cat., Auckland City Art Gallery, Auckland 1995.

38. On versions of this text and their significance see Elizabeth Childs, 'L'esprit moderne et le catholicisme: le peintre écrivan dans les dernières années' in *Gauguin/Tahiti: l'atelier des tropiques*, 2003, pp.274–89.

39. Paul Gauguin, letter to William Molard, August 1897, Tahiti in Paul Gauguin, *Letters to his Wife and Friends*, trans. Henry J. Stenning, Boston 2003, p.207.

40. On the genesis and meaning of this work see George T.M. Shackelford, '*D'où venons-nous? Que sommes-nous? Où allons nous?*' in *Gauguin/Tahiti: l'atelier des tropiques*, 2003, pp.218–51.

41. On dealings between Gauguin and Vollard see *Cézanne to Picasso: Ambroise Vollard, Patron of the Avant-garde*, exh. cat., Metropolitan Museum of Art, New York 2007, pp.61–81.

Index

A

Académie Colarossi 8
Aha oe Feii? 23; fig.53
Ancien Culte Mahorie 22; fig.16
Arles 16–17
Arosa, Gustave 6–7
Arosa, Marguerite (1854–1903) 7
The Artist's Mother 6; fig.22

B

Bather in Brittany 13; fig.30
Bebe 25; fig.59
Bernard, Emile (1868–1941) 14–15
 Breton Women in the Meadow
 14; fig.10
Blue Roofs, Rouen fig.24
Bréton Wrestling 13–14
Brittany 12, 13–15, 19

C

ceramics 12, 18; figs.26, 27, 37
Cézanne, Paul (1839–1906) 8
 The François Zola Dam 11; fig.8
 Landscape, Study after Nature
 8; fig.5
Chaplet, Ernest (1835–1909) 12
Chazal, Aline Maria (mother;
 1825–1866/7) 6–7; fig.22
Christ in the Garden of Olives 20–1;
 fig.43
Clovis Asleep 11; fig.25
Coming and Going, Martinique 13;
 fig.29
Corot, Jean-Baptiste-Camille
 (1796–1875) 7, 16
Courbet, Gustave (1819–77) 7
 Bonjour Monsieur Courbet 17

D

Daumier, Honoré (1808–79) 7
Degas, Edgar (1834–1917) 8, 9, 24
 Young Spartans Exercising 9; fig.7
Delacroix, Eugène (1798–1862) 7
Durand-Ruel, Paul (1831–1922) 24

E

Eiffel Tower 18; fig.13
L'esprit moderne et le catholicisme
 25
Eu haere ia oe 23; fig.54
Exposition Universelle (1889)
 17–19; fig.13

F

Figures in a Garden 8; fig.3

G

Gauguin, Aline (daughter) 9, 26
Gauguin, Clovis (father; 1816–1851) 6
Gauguin, Clovis (son) 9, 11; fig.25
Gauguin, Emil (son) 7, 8
Gauguin, Guillaume (grandfather) 6
Gauguin, Mette (wife; 1850–1920)
 7, 8, 9, 11, 21, 26; fig.23
Gauguin, Paul (1848–1903) figs.1, 19
 birth and early life 6
 character 5, 6
 children 7, 8, 9, 11, 23, 26
 health 13, 24, 25, 26–7
 income 6–7, 9, 11, 16–17, 20–1,
 24, 25
 marriages 7, 9, 11, 21, 23, 26
 mythologized identity 14
 titles 22
Good Morning Mr Gauguin 17;
 fig.36
The Great Buddha 25; fig.20
Green Christ 20; fig.40

H

Haere Mai 22; fig.45
Harvest, Le Pouldu 19; fig.30
Huot, Juliette (1866–1955) 20
Huyghe Sketchbook 16; fig.12

I

Impressionists 8, 9, 11
In the Vanilla Grove, Man and Horse
 22; fig.46
Ingres, Jean Auguste Dominique
 (1780–1867) 16

L

Landscape 7; fig.2
Laval, Charles (1862–94) 12–13;
 fig.28
Le Pouldu 19; fig.39
The Little One is Dreaming 9; fig.6
The Loss of Virginity 20; fig.42

M

Maison du Jouir 27; fig.21
Mallarmé, Stéphane (1842–98)
 20–1
Manao Tupapau (oil) 23; fig.52
Manao Tupapau (woodcut) 25;
 fig.18
Marquesas Islands 5, 25–7
Martinique 13; fig.29
Meyer de Haan, Jacob (1852–95)
 19; fig.38
Mirbeau, Octave (1848–1917) 20
Monet, Claude (1840–1926) 9
Morice, Charles (1861–1919) 24–5

N

Nabi movement 18–19
Nafea faaipoipo 23; fig.55
navy 6
Nevermore 25; fig.58
New Zealand 25
Noa Noa 23, 24–5

O

Ondine 14; fig.31
Orléans 6
Oviri 12; fig.26

P

painting 7–8
Panama 12–13
Parahi Te Marae 22–3; fig.47
Peru 6
Pissaro, Camille (1830–1903) 7,
 8, 9, 20
 A Wool-Carder 8; fig.4
Polynesia 6
Pont-Aven 12
Portrait of Mette Gauguin 9; fig.23
Portrait of Jacob Meyer de Haan
 19; fig.38
Portrait of Susan Dambridge 22;
 fig.44
printmaking 25; fig.18
Puvis de Chavannes, Pierre (1824–98)
 Young Girls by the Sea 13; fig.9

R

Raphael (1483–1520) 16
Renoir, Pierre-Auguste (1841–1919) 9
Rousseau, Théodore (1812–67) 16

S

Salon 8
Salon des Indépendants 11
Schuffenecker, Emil (1851–1934)
 7, 8, 11, 13, 17, 20; fig.35
The Schuffenecker Family 17; fig.35
sculpture 6, 9, 27; figs.21, 23, 48
Segalen, Victor (1878–1919) 5, 27
Self-Portrait with Portrait of Bernard
 14–15; fig.34
Self-Portrait Vase 18; fig.37
Sérusier, Paul (1864–1927) 19
 The Talisman 10; fig.14
Seurat, Georges (1859–91) 11
Shell Idol 23; fig.48
Still Life with Profile of Laval 12;
 fig.28
*Still Life with Sunflowers and
Mangoes* 25; fig.56
Study of people, 'annamites'... 19;
 fig.15

T

Tahiti 20, 21–4
Tahitian Woman with Flower 23;
 fig.49
Te arii vahine 25; fig.57
Teha'amana Has Many Parents 23;
 fig.51
Tristan, Flora (grandmother;
 1803–44) 6
Two Tahitian Women 23; fig.50

V

van Gogh, Theo (1857–91) 12,
 15–17, 18, 20
van Gogh, Vincent (1853–90)
 15–17, 18
 Sunflowers 16; fig.11
Vase decorated with Breton scenes
 12; fig.27
Vision of the Sermon 14; fig.33
Vollard, Ambroise (1866–1939) 27

W

Where Do We Come From?... 27;
 fig.60
*The Wine Harvest at Arles (Misères
Humaines)* 14; fig.32

Y

Yellow Christ 20; fig.41

First published 2010 by order of the Tate Trustees
by Tate Publishing, a division of Tate Enterprises
Ltd, Millbank, London SW1P 4RG
www.tate.org.uk/publishing

Reprinted 2010

© Tate 2010

A catalogue record for this book is available from
the British Library

ISBN 978 1 85437 936 8

Designed by Anne Odling-Smee, O-SB Design
Colour reproduction by DL Interactive Ltd, London
Printed in Italy by Conti Tipicolor, Florence

Front cover: Paul Gauguin, *Nevermore* 1897
(detail of fig.58)
Frontispiece: Paul Gauguin, *Te arii vahine* 1896
(detail of fig.57)

Measurements of artworks are given in
centimetres, height before width.

Mixed Sources
Product group from well-managed
forests and other controlled sources
www.fsc.org Cert no. DNV-COC-000117
© 1996 Forest Stewardship Council
FSC

Photo credits

All images copyright the
owner of the work unless
otherwise stated below

© ADAGP, Banque d'Images,
Paris 2010 fig.10
Photo © Armand Hammer
Collections fig.36
© Bridgeman Art Library fig.1
© The Trustees of the British
Museum fig.18
Photo © The Samuel Courtauld
Trust, The Courtauld Gallery,
London fig.23
© Ex colección Di Tella MNBA
fig.30
Photo © The Israel Museum
by Meidad Suchowolski fig.12
Photo © Pernille Klemp figs.6,
32, 37
Photo © Kunstmuseum Basel,
Martin P. Bühler fig.55
Photo © Mary Evans Picture Library
fig.13
Photo © Ny Carlsberg Glyptotek,
Copenhagen. Ole Haupt figs.3, 49
RMN (Musee d'Orsay)
 Jean-Gilles Berizzi fig.15
 Gerard Blot fig.48
 Herve Lewandowski figs.9, 14,
 16, 26, 35
 René-Gabriel Ojéda fig.21
© 2010. Photo Scala, Florence
20, 57
© 2010. Albright Knox Art Gallery/
Art Resource, NY/ Scala, Florence
figs.41, 52
© 2010. Image copyright The
Metropolitan Museum of Art/ Art
Resource/ Scala, Florence fig.50
Photo © 2009. Digital image,
The Museum of Modern Art,
New York/ Scala, Florence fig.38
Photo © 2010. White Images/
Scala, Florence fig.53
© The State Hermitage Museum.
Photo by Vladimir Terebenin,
Leonard Kheifets, Yuri Molodkovets
figs.54, 59

Full collection credits

Gift of Mr and Mrs Charles Deering
McCormick, 1980.613, The Art
Institute of Chicago fig.51

The Cleveland Museum of Art. Gift
of Mr and Mrs William Powell Jones
1978.63 fig.31

Chrysler Museum of Art, Norfolk,
VA. Gift of Walter P. Chrysler, Jr.
fig.42

Indianapolis Museum of Art,
Samuel Joseowitz Collection of
the School of Pont-Avon, through
the generosity of lilly Endowment
Inc., the Josefowitz Family, Mr and
Mrs James M. Cornelius, Mr and
Mrs Leonard J. Betley, Lori and Dan
Efroymson, and other Friends of the
Museum fig.28

Norton Museum of Art, Florida. Gift
of Elizabeth C. Norton, 46.5 fig.43

Philadelphia Museum of Art: Gift
of Mr and Mrs Rodolphe Meyer de
Schauensee, 1980 fig.47

Solomon R. Guggenheim Museum,
New York. Thannhauser Collection,
Gift, Justin K. Thannhauser, 1978
figs.45–6

Colección Carmen Thyssen-
Bornemisza en depósito en el
Museo Thyssen-Bornemisza fig.29